EXPLORING UNDERWATER PHOTOGRAPHY

EXPLORING UNDERWATER PHOTOGRAPHY

John Christopher Fine

Plexus Publishing, Inc.

AN
INTERNATIONAL
OCEANOGRAPHIC
FOUNDATION
SELECTION

CONTENTS

INTRODUCTION

BEFORE YOU DIVE IN

The letter in the envelope was from my diving buddy, but it was quickly put aside when I spotted the snapshots tucked between its pages. I looked through them eagerly, smiling at my own enthusiasm. You'd think that someone who had been on as many photographic expeditions as I have would be blasé by now. Besides, I had taken hundreds of color slides of my own on that same dive trip.

Nonetheless, it was a thrill to view the scenes of our shared venture. And isn't this what photography is all about? While it may sound like a script for a commercial to say that we are attracted to photographs as a way of sharing memories, it's true. Who can deny the satisfaction of seeing family, friends and vacation sites in pictures, especially when those pictures grab the eye with their beauty and intensity.

A major film manufacturer has adopted an advertising philosophy that enjoyment of photography should, without the aid of gimmicks, sell itself to the public. In its advertising, the company relies on beautiful images to attract people to the hobby rather than on a hard sell of the product line.

It works. Somewhere in the eye and mind of everyone is an

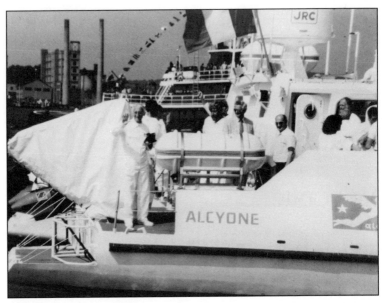

Jacques-Yves Cousteau uses an instant-print camera to record the arrival of the Alcyone in New York harbor.

appreciation for beauty, for symmetry, even for asymmetry. The artistic eye is drawn to pictures in the same way it is drawn to life. A picture somehow intensifies a moment in time, freezes a frame of life in a way our own memories cannot. The photograph is history, or at least a moment's perception of history, subjective and objective at the same time.

In addition to the sheer enjoyment and opportunities for artistic expression, underwater photography provides an educational experience encompassing far more than "nuts and bolts" knowledge. The concentration required to take good pictures underwater develops powers of observation which might never come about in any other way. As a consequence, underwater photographers often perceive and learn things about their environment that their crowbar-wielding counterparts never experience.

The pleasures and profits to be gained from underwater photography are matched by the challenge. All forms of photography require concentration and discipline, but working with cameras underwater

demands the added skills of coordination and a quick eye for composition. Some amateur land photographers either dismiss discipline entirely or consider it secondary to persistence. They can indulge in an almost wasteful expenditure of film in multiple takes to ensure at least one perfect exposure. Underwater, the story is different. Even sessile organisms may offer only one chance for that ideal shot.

Effective pictures of marine life are the combined result of a sound knowlege of plant and animal behavior and a high degree of technical skill to document it creatively on film. Coordination of the entire body while the diver's mind gauges camera settings and the proper strobe angle must be as instinctive as basic principles of diving safety. A good diver can learn to be a good underwater photographer. A struggling, inexperienced diver might, in the long run, take better pictures by devoting time to advanced instruction in basic underwater skills before loading down with photographic equipment that will only add to the difficulty of a dive.

For the lover of animation and action who is ready to take on the challenges, the development of reasonably priced film and video equipment has added new dimensions to underwater photography. Underwater video units offer instant gratification, enabling divers to view takes immediately upon surfacing. Similarly, the invention of instant slide film now allows divers to surface, pop the roll of film in a processing machine and immediately project the results. Modern technology has helped simplify the technique of underwater picture-taking without diminishing the challenge or adventure.

My approach to teaching underwater photography is based on a similar philosophy of simplification. The method I favor stresses a few elementary rules—rules that ease the work of picture-taking in an alien environment, often under adverse conditions. These fundamental guidelines provide a frame of reference that will result in roll after roll of creditable pictures. Former students of mine repeatedly comment on the basic simplicity of what they were taught in my underwater photography course. "I came away with a few basic principles," remarked one, "and they turned out right. I tried to tell my friend on the Red Sea dive, but I guess it seemed too simple to be true. She's very disappointed with her pictures. Mine turned out great."

3

Great pictures should not be a surprise. The guidelines outlined here (see chart on right) and expanded upon in the following chapters will lend consistency to picture-taking. The pride and satisfaction you gain, as with all learning experiences, will reflect your efforts as a student. As an initial task, become familiar with your teacher—the book you hold. Skim through the chapter headings and note how the book is organized. Plan your second, more serious reading accordingly. If you've already bought all the photographic equipment you'll need, skip that section. Don't worry that there are bigger or better units or that you've sunk a lot of money into something the book suggests might better be avoided. You own it, so read those parts of the text that demonstrate how you can adapt the machinery to the purpose at hand.

If you have not yet bought equipment, don't. Read the entire book carefully, then go back over the sections explaining equipment. Think through your philosophy for taking up underwater photography. Study the major photography magazines and the camera wholesale price lists, keeping in mind that the equipment you buy is an investment. The criteria I present will guide you in making your investment a sound one.

In general, the text unfolds much as my course would in the classroom, at poolside, and on the open water. There are three major sections: equipment, technique, and a final section combining aspects of processing, protection, and presentation. While it is impossible to directly answer your specific questions, the use of questions asked and opinions shared over the course of my teaching history and personal learning experience will help provide a common footing. And, regardless of the differences in our diving and photography experience, we share a starting point that prompted me to write this book and you to read this far. The oceans represent the last frontier, the last great wilderness of planet Earth. To explore their depths and share the adventure with others is a commitment to enjoy and better understand the stunning beauty and importance of this vast natural reservoir that is the fountainhead of life.

Some Basic Rules For
The Underwater Photographer

1. Drill your diving skills. Emergency procedures and underwater communication must be practiced to perfection and executed with a dependable buddy. Knowing where a diving buddy is and what the buddy is doing is a must at all times, despite the concentration required to take pictures. If there are any doubts about a diver's ability to be a responsible buddy and simultaneously take pictures, choose one activity or the other. While one diver takes pictures, the other watches.

2. Buy the best underwater photographic equipment the first time round. If you cannot afford the best equipment suited to present and projected needs, delay buying until you can.

3. Avoid fancy gadgets. Brackets, light meter holders, arms, optical or plastic viewfinders and other assorted gadgets may appear helpful, but they often prove unnecessary. Camera, strobe and meter—these are the three separate and unattached items that give the

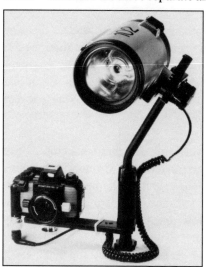

diver the flexibility to shoot creative pictures. Manipulating a strobe on an arm, jointed or not, never substitutes for the flexibility of the human hand. Reliance on brackets and arms can result in static, flat pictures or subjects that cooperate with a single-plane system. If you can learn underwater photography without reliance on gadgets, you will eventually master the equipment and enjoy its full potential.

Nikonos V underwater camera on bracket with strobe

5

Basic equipment in use in underwater photography lab

4. Use Kodachrome or a comparable film that renders pleasing tonality to reds and oranges in underwater settings that require artificial light. Ektachrome is an excellent film, especially for open-water shots and for those using natural light at distance. Exclusive reliance on Ektachrome film underwater, however, is an old and unnecessary tradition that dies hard. Bury it.

5. Consider your composition carefully and then work close—take the picture as close to the subject as possible. Composition begins with the choice of a subject and the search for its points of interest. Animal behavior can be one of the most interesting pursuits of an underwater photographer. A slow and gentle approach generally works best. Patience is rewarded.

People are interested in people, so don't overlook the reactions of divers to marine life. Feeding fish, for example, creates many interesting photographic possibilities. Human interest adds zest,

6

Feeding fish is one way to create an interesting photograph.

proportion and a sense of identity to a picture.

6. Simplify! Use the same speed film all the time. Use the same shutter speed all the time. This leaves only distance and aperture as adjustable factors. Simplifying the basic maneuvers prior to taking a picture allows the photographer to concentrate on composition. In a diving situation, the less that has to be remembered the better.

Part One

Equipment

Underwater photography, like any form of filmmaking or picture-taking, involves mechanical tools and skills. Acquiring the appropriate equipment and becoming familiar with it is a threshold task. Growing satisfaction with the photographs you take will parallel your growing skill in using the camera and its accessories.

This section thus deals with your starting point—knowing what underwater photographic equipment is on the market and choosing the equipment best suited for your purpose. The section starts off with a discussion of basic camera and film choices, then describes accessories, attachments and lighting considerations. It winds up with some advice on upkeep and repair of your equipment.

Mastering the mechanical aspect of underwater photography will come, of course, only with time and practice. Even experienced photographers must allow a period of time for testing and experimentation before feeling comfortable with a new camera system. Choosing proper equipment at the outset, however, and establishing solid principles of usage throughout this initiation period will pay dividends in the future, when more subjective considerations of photography can be based on a sound knowledge of hardware.

Chapter One

Cameras and Film

Novice underwater photographers share a common emotional disorder—confusion. Putting the cart before the horse, they must make important decisions concerning camera selection and film choice before they get their feet wet. The well-intended suggestions of friends, salespersons, and a variety of experts are usually contradictory and based on *their* needs and preferences. Rather than add to the confusion, let me point you in the right direction by explaining the basic camera and film choices that will confront you and how you can make a selection that best balances your personal needs with the basic needs of all underwater photographers.

Considerations in Selecting Underwater Photo Equipment

The question asked most often by novice and experienced photographers has two parts: "What do you think is the best equipment?" and "How much does it cost?" The quick answer to both questions is that the best does not always cost the most when it comes

11

to underwater photographic equipment. For example, one of the most expensive underwater electronic strobes now on the market is a monstrosity for the gadget minded. In the same manufacturer's line, the second less expensive strobe is a dependable workhorse. The less expensive strobe, in my opinion, is not only the best for the money but also the best for the use intended.

Many professional underwater photographers writing for magazines and offering advice to prospective buyers get the product for free as an inducement to evaluate it favorably. The practice of receiving products free for testing and evaluation is not improper, but the consumer must keep in mind that reviewers are not putting out cash to buy the product. The prudent shopper takes nothing at face value. Hype advertising or product evaluations in dive magazines must be reviewed by a careful consumer who asks questions, evaluates, then makes an informed choice.

Lugging bulky photo gear with dive gear can be a chore. If you travel a great deal, the compact camera is for you.

What do you think is the best underwater photo equipment? That question can usually be answered by the diver-photographer asking it. Divers about to purchase underwater photographic equipment should first note their requirements. A few basic questions serve as a guide:

How often will I use the piece of equipment?

How many times did I dive last year?

Will I use the camera for any other purpose?

Can I?

Do I travel a lot?

Is the equipment too bulky, heavy or fragile?

Is the particular item a popular model, adding to its resale value if I decide to sell it in the

12

future?

What does it cost and how much am I willing to spend?

Will the system grow with my needs as I gain experience as a photographer?

Is the film size and format practical and suited to foreseeable future use of the pictures?

The choice of the "best" underwater photo equipment thus depends on what is best for the individual diver, who must match the compatibility of the product with its intended use. A diver who travels by air a great deal, where overweight or bulky baggage is a problem, may not want a single lens reflex camera in an aluminum housing. Camera housings are bulky and heavy. If housings are to be transported safely, they require separate padded cases to protect them against abuse by baggage handlers. A small self-contained 35 mm underwater camera that can be carried in an attache case or slung

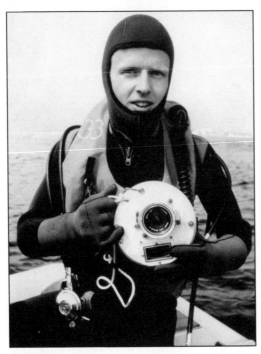

This Northeast diver made his own camera housing from scratch.

13

around the neck may be better suited to the traveling diver's needs.

Likewise, a person who dives twelve times a year may be wasting money buying a strobe with rechargeable nickel-cadmium batteries. The occasional diver is usually out to shoot pictures as souvenirs of

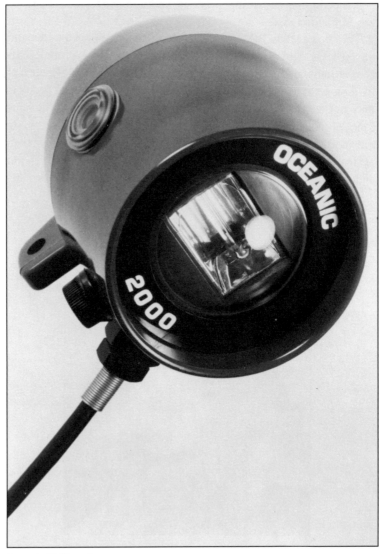

Oceanic 2000 strobe

the dive trip or to include them in an album for friends to leaf through. A small flashlight battery-powered strobe may be all that this diver needs to provide pleasing fill lighting for underwater portraits of family or friends.

Cost of equipment, therefore, is a relevant consideration in one's analysis of available equipment. Portability, durability and use, including potential for use on land, are among the other prime considerations when choosing underwater photographic equipment. Finally, the desired format must be determined—whether sixteen, eight or Super-Eight millimeter for movies; whether to take video instead of films; or thirty-five, one-ten or large square format for stills. The choice of format is a threshold question in considering the purchase of underwater photographic equipment.

The Camera

I smile each time I read a book or article on photography describing the camera as "nothing more than a light-tight box with a means to control the entry of light which strikes the film contained inside." This oversimplification is of little help to anyone who has tried to sort out or repair a camera's myriad springs, levers, screws, switches and internal meters. Nor does it assist the prospective buyer faced with the choice of a wide variety of cameras.

For underwater use there are actually two basic types of cameras, self-contained waterproof models or cameras in housings. One manufacturer makes plastic housings for almost every imaginable camera on the market. Stock aluminum housings are available from other manufacturers for Nikon, Canon, Hasselblad and Pentax cameras. Many of these housings can be adapted for use with other cameras as well.

Self-contained underwater cameras are manufactured by Hanimex, Minolta, Nikon, Eumig, Aquamatic and a few others. As the popularity of underwater photography grows, along with the demand by boaters and skiers for weatherproof cameras, many more submersible cameras will appear on the market. Some of the self-contained waterproof cameras now available even come with their own built-in flash units. This cost-saving feature puts the realm of

15

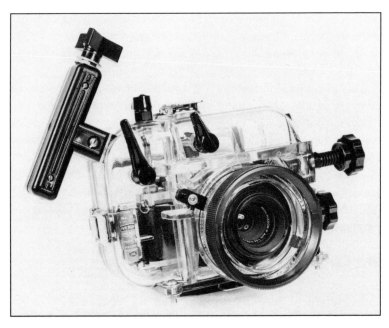

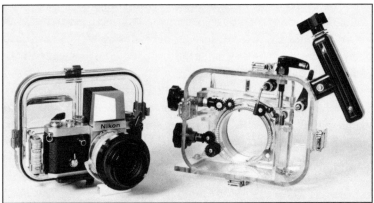

Plexiglass housings

underwater photography into the hands of anyone who enjoys snorkeling.

All cameras have the same basic component parts. Their arrangement may differ and the nomenclature may change from manufacturer to manufacturer, but an understanding of basic camera

16

Aluminum housing with strobe that moves on its own housing

design can be applied to any individual make. A few terms bear explanation. Although the treatment here will be superficial, any basic text on photography will supplement this information.

The abbreviations SLR, which stands for single lens reflex, describes a camera viewing system which is through the lens by means of a mirror and prism. Rangefinder cameras and cameras with built-in viewfinders do not enable the photographer to see the subject through the camera's lens. Such systems allow the photographer to see and frame the subject by means of scored glass or plastic screens.

Cameras are equipped with a shutter or movable curtain that opens and closes when the camera is fired. The amount of time the shutter stays open determines the exposure of the film. This is called shutter speed. Shutter speeds are expressed in seconds or fractions of seconds. A shutter speed of 1,000 means one-thousandth of a second. A shutter speed of 1 means one second.

As a rule of thumb, the faster the shutter speeds of a particular camera, the finer and more expensive the camera. The shutter mechanism is machined to the fineness of the fastest speed. A Nikon F3 has a maximum 1/2000th of a second shutter speed, the Nikon FE 1/1000th, the older Nikonos underwater cameras 1/500th, and the newer Nikonos V 1/1000th. Shutters may be held open for as long as the trigger is depressed when the setting is on B.

Popular shutter varieties include the focal plane and leaf shutters. The Rollei camera uses the leaf shutter, which opens and shuts again rapidly. This means that a strobe used with a leaf shutter camera will

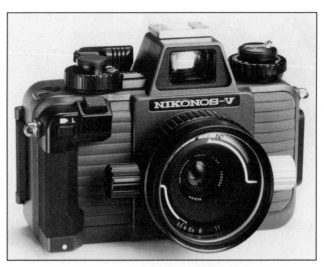

Nikonos V underwater camera with UW- Nikkor 28 mm f/3.5 lens

be in synch at any shutter speed. SLR cameras and the Nikonos underwater camera use the focal plane shutter, which in effect opens and closes like curtains. The opening and closing speed of the curtains and the gap between them, which is adjustable as the camera's shutter speed is changed, determines the exposure of the film to light. Focal plane shutters on most underwater cameras are synchronized at a maximum speed of 1/60th or in some cases 1/90th of a second when electronic strobes are used. Camera shutter speeds are arranged so they double or divide in half the setting as it is increased or decreased.

The lens opening, which is also adjustable, is called the aperture. The aperture is simply the size of the hole in the lens through which the light passes. Aperture diameter is designated by f stops, which are the diameter of the aperture divided into the lens focal length. The larger the f stop number, the smaller the aperture. When the diameter of the aperture is changed from f stop to f stop, each stop doubles or divides in half the lens opening.

Using the camera's controls, the photographer can adjust the lens and the shutter speed to obtain the desired results. The smaller the lens opening, or aperture, the greater the depth of field. Thus, to increase the depth of field with a particular film stock, a photographer

18

Formaplex underwater camera with strobe and close-up tines

might want to close down, or stop down, the lens and shoot at a slower shutter speed. With a telephoto lens, where any movement will result in a blurred image, the photographer may want to increase the shutter speed and widen the aperture.

Equal values can be worked out quite simply. A camera with the same film stock, set at f/5.6 and 1/60th of a second yields the same exposure as a camera set at f/8 and 1/30th of a second or f/4 at 1/125th of a second.

The focal length of the camera lens is the distance from the film plane to the lens' optical center, again with the lens focused at infinity and widest opening. Lenses with long focal lengths are telephoto lenses. Lenses with short focal lengths are wide-angle lenses. The angle of view of the lens is technically called its angle of acceptance. The longer the focal length, the narrower the angle of acceptance of a

19

Nikonos V with 15 mm lens

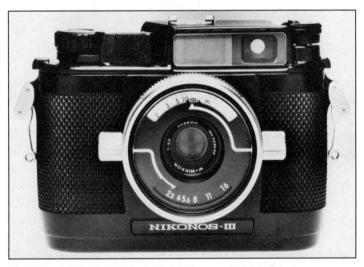

The Nikonos III underwater camera is still the workhorse of the pros.

20

camera lens.

In discussing cameras, photographers designate them by their focal lengths. A standard lens is used in these comparisons. The term "normal" or "normal lens" is widely used, but it is technically correct to refer to the camera's "standard lens." The film dimensions of 35 mm cameras are 24 mm x 36 mm. Film dimensions should not be confused with focal length nomenclature for cameras. Using the standard 50 mm lens, the focal length or measured distance when set at infinity, from film to center of the lens, is 35 mm.

Depth of field refers to the area in focus behind and in front of the subject. Nikonos underwater lenses have an easy-to-read depth of field scale right on the lens. Subjects will be in focus at distances indicated on the lens, between the two scales. Turning the control knob, one will quickly appreciate the fact that depth of field increases as the lens is stopped down. Wide-angle lenses offer greater depth of field than telephotos. As will be discussed in more detail in later chapters, there is very little depth of field in macro or close-up photography.

Through-the-lens or SLR cameras eliminate the guesswork of focusing. Looking through the lens of an SLR camera, what the photographer sees is what the photographer gets. Nikonos and other viewfinder cameras require estimation of the subject to camera distance. The refraction of light in water, passing through the air in the diver's mask, is identical to the effect caused by refraction of light through the air space of the camera as it passes through the lens. Objects in sea water appear closer by 25% and larger by 33%. The distance the photographer estimates and sets on the lens is the apparent distance. If the photographer took a ruler underwater, the ruler would measure real distance and the focus would be off. To use measured distances underwater, 25% would have to be subtracted from the measured distance before setting the focus. Since apparent distances are used in setting the focus, measuring distances underwater is impractical and unnecessary. Estimating distances will improve with practice.

The older Nikonos underwater cameras had an uneven advance. Frames would come back improperly cut by the processing labs or with thick black lines between frames because of this uneven spacing.

The newer models improved the uneven advance problems, but it is still a good idea, after inserting a new roll of film in the camera, to hold the film end in place with one's thumb, then rewind it into its roll so that the film is taut in the roll, but not too tight. This will help to ensure even film advancement.

When a roll of film is finished, wait until the camera has been washed and dried before rewinding it. Rewinding a camera underwater doesn't save time. Rewinding underwater may cause the "O" ring to leak and admit water into the camera. It is a good idea to rewind the camera with the lens cap in place and the trigger discharged. A shutter can sometimes remain slightly open when there is tension on the shutter release. This can cause a line of light to enter the camera and score the film.

Each still or movie camera has its own special features. While the basic functioning and nomenclature is the same, the best way to understand the functioning of one's own camera is to study the manufacturer's instruction booklet, then practice shooting a roll of film on land before taking the camera underwater.

Film Size and Format

Movie Film

When choosing an underwater movie camera, the filmmaker's first consideration is what size film will best suit the intended use of the movies. No size less than 16 mm is acceptable for most commercial and professional applications of movies. While some television stations adapted Super Eight to their use, especially for spot news reports, this situation was rare. Color video taping has widely replaced the use of film altogether in TV news departments. Film footage, whatever its size, can be adapted to commercial use, but the chance encounter of an amateur filmmaker with a dramatic piece of history is relatively rare. The movies taken by an amateur of President Kennedy's assassination were enhanced scientifically, but only at great cost.

Showings before general audiences, including underwater film festivals, as well as general professional and commercial use,

22

Video crew on location at Scapa Flow, where the fabled German World War I battleships scuttled in deep water

mandate the use of 16 mm film. Nonetheless, there are many drawbacks to the use of this format except by professional film companies. At list price the cost of a 100-foot roll of 16 mm color film is about $19. The cost of processing and printing 16 mm color negative film is approximately $0.35 per foot. Film stock in the 16 mm format thus runs about $54 per 100 feet. Expense may well put 16 mm film beyond the reach of many amateur filmmakers.

With the popularization of Super Eight photography, amateur 16 mm camera technology came to a near standstill. After spending from $2,500 to $25,000 for a new 16 mm camera, the sixteen enthusiast is generally left with fixed-focus lenses without automatic features. Because 16 mm has become unpopular among amateurs due to the expense, bulk and lack of "sophistication," except in the most expensive models, bargains are usually available in older model 16 mm movie cameras. The Bolex H 16 with a single lens or triple turret is a standard workhorse. A careful buyer can pick up a used Bolex in a camera store for between $65 and $200, depending on the condition, lens configuration and the shop owner's difficulty in selling a white

elephant. The 10 mm wide-angle lens is about the most practical for underwater use with the Bolex.

Professional underwater cinematographers use the Eclair, Beaulieu, Rebikoff or Arriflex in their underwater work. Older rigs consisted of a Kodak K100 movie camera in an aluminum housing. At one time, 35 mm was the standard underwater movie format for Hollywood films. More recently, audiences have been wowed by 70 mm Eyemax projections that fill the immense screen with wrap-around color. While major Hollywood studios still shoot their underwater sequences in 35 mm, the standard professional underwater work is 16 mm.*

John Stoneman with housed Arriflex underwater motion picture camera

Photographers may question why the filmmaker cannot blow up or reduce the size of the format after shooting—for example, to shoot in Super Eight and have it enlarged to 16 mm. This can be done and sometimes is done. In spite of the drawbacks of bulk and cost, some underwater cinematographers shoot their films in 35 mm, then reduce the edited film to 16 mm in the laboratory for commercial prints. The resulting film, having gone from a larger to a smaller format, has fine clarity and resolution. Resolution and clarity are lost when a Super Eight film is blown up to 16 mm. The projected film appears grainy. For most professional underwater cinematographers, especially the independents, 35 mm or 70 mm is too expensive and too bulky to use, and Super Eight is unsatisfactory for large-screen projection. The format of choice then is 16 mm.

* See color section.

Sixteen mm film is ideal for cueing. Sound tracks can be added after filming or contemporaneous recordings can be made. Most professionals stay away from 16 mm cartridge film cameras, although many amateurs using the 16 mm format like the convenience of the cartridge load. Automatic electronic-eye cameras were available at one time for 16 mm cartridge film. These cameras, smaller and more convenient, could be put in relatively inexpensive underwater housings.

Double perforation film—film with sprocket holes cut on both sides of the 16 mm roll—allows for more precision on the editing bench. Double perf film is preferred over sprocket-on-one-side film by most professional underwater filmmakers. Since editing is the key to successful underwater cinematography, post-production flexibility is an important factor in the choice of film stock.

Projection of the final print is a relatively simple matter for a film made in 16 mm. Most school systems, libraries, churches and camera store rental departments have 16 mm projectors. The cost of a 16 mm projector with sound features ranges from $500 to $800. They are more expensive than a good Super Eight projector, but reasonable enough compared to the cost of camera and film. Larger format 35 mm or 70 mm movie films require special projection equipment, usually available only in movie theatres.

The most common movie camera in use today by amateur underwater filmmakers is the Super Eight. Relatively inexpensive cameras can be purchased with an assortment of features, including electronic shutters for automatic exposure, zoom lenses and even sound-cueing features. The cameras are compact and can be housed in aluminum or plastic cases for use underwater. Newly developed lenses and shutter systems have given automatic Super Eight cameras excellent low-light capabilities. This is a boon for underwater filmmakers who wish to take advantage of high-speed Ektachrome or Super Eight film stock. Self-contained underwater cameras are available from Eumig. Such water- and weather-proof cameras have found wide acceptance in Europe among divers as well as sailing and skiing enthusiasts.

Super Eight film is available in a variety of speeds, including fast film. The 50-foot cartridge load capability enhances its convenience underwater. One Japanese camera maker now produces what is

called the Single Eight movie camera and cartridge. The unit is marketed with its own plastic underwater housing. While the slim size of this unit and its convenient grip enables single-handed operation underwater, a popular feature among some amateurs, the camera can only be used with the manufacturer's film, which requires special processing. Single Eight movie cameras are limited in the interchangeability of films, and thus the camera's flexibility is limited. Projection of the Japanese Single Eight film usually yields grainy and inconsistent results—adequate and often pleasing souvenirs of a dive trip, but frustrating drawbacks for the serious and demanding underwater filmmaker.

Kodak's line of low-light Super Eight movie cameras has become quite popular among amateur underwater filmmakers. The Kodak cameras are widely used with Kodak's fast Super Eight film. Kodak's XL series of movie cameras were designed to be held flat in both hands in front of one's face, which accounts for the camera's two fin-like grips. This feature, however, adds unnecessary bulk to a housing when adapted for underwater use in its round tubular case. In addition to its bulk, the camera in a plastic housing requires both hands to operate underwater. The Kodak low-light lens system has comparable counterparts in traditionally shaped movie cameras that allow the use of slimmer housings.

While it is relatively expensive, the self-contained Eumig Super Eight movie camera, made in Japan, offers great flexibility and convenience for the underwater filmmaker. As the camera gains acceptance and becomes more popular, the price inevitably will become more competitive, and Eumig or similar self-contained models may pre-empt housed Super Eights.

Still Photography

The early snobbishness among magazine and art book publishers for large-format negatives in still photography has all but disappeared. Cost increase in film and processing and the expense of making color separations, as well as the flexibility of 35 mm photography, are all factors that have made the 35 mm the choice of professional and amateur photographer alike. Even large blow-ups and full-color

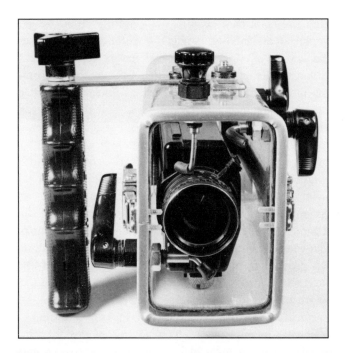

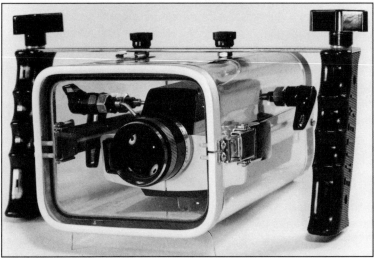

Super Eight movie housings

magazine and book pages can be made from 35 mm. Advances in lithographic art and laboratory negative techniques have made the 35 mm the choice of most professional nature photographers. The Hasselblad, Rolleiflex, Pentax or other large or square format film cameras in aluminum or plastic housings render excellent professional results when used underwater. Cost, bulk and inconvenience, however, have practically retired large-format equipment in favor of 35 mm.

Thirty-five millimeter film comes in a variety of types and speeds, including many specialty loads for technical and professional uses. Cartridge or roll film is available in 35 mm. Some amateur photography enthusiasts enjoy the 110 Instamatic, and flip-flash pocket cameras in inexpensive plastic housings have become popular for underwater use in recent years. Depending on one's goals, the 110 cartridge provides adequate snapshots. Commercial use of 110 is not feasible, however. Most serious underwater photographers quickly become frustrated with the 110 format and end up relegating their first underwater rig to a closet or selling it in favor of a 35 mm.

One housing manufacturer sells a waterproof case for a Polaroid camera. The pictures are caught in a sealed plastic lip under the housing. While this gadget is the ultimate curiosity, such gimmickry is not practical for underwater use. A serious amateur is better off with a format that will enable growth as new skills are acquired. Equipment in still photography that is flexible ends up being permanent. Gimmicks and formats other than 35 mm or larger are quickly outgrown. The underwater photographer with 110 or similar equipment is usually left with something that has little resale value.

Video

The amateur video market has grown by leaps and bounds as the cost of compact video cameras and recorders has dropped. While most housed units are still bulky, smaller tape sizes permit battery-powered units to be taken underwater. Tapes made on the smaller format can easily be transferred to larger format. The relative ease in editing video tapes has made them increasingly popular for professional television production as well as amateur use. Business profes-

28

sionals maintain that theatrical video projection will be a highlight of future years if video technology continues to develop at its present rate.

Video offers some obvious advantages to the underwater photographer. On one occasion, for example, I was filming in 16 mm while a friend was shooting video of the same event. His lack of concern over the cost of the tape was apparent. Tape could be used and kept or erased and used over again. The video tape, in addition to being very inexpensive, far outlasted even my 400-foot movie rolls. Unfortunately, fidelity in video is not comparable to film. The picture often has poor image quality. Technological improvements are being made at a rapid pace, however, and video may one day totally replace film for both television production and theatrical projection.

The inventor of the cathode ray and other electronic instruments, Dimitri Rebikoff, continues to pioneer development of underwater video systems. The Rebikoff Chromos underwater video camera is a self-contained, cable-free, autonomous color video system. Rebikoff video units are state of the art, used by the U.S. Navy and professionals around the world.

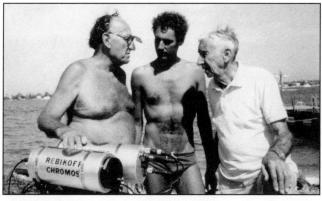

Author flanked by diving pioneer Philippe Tailliez (r.) and Dimitri Rebikoff, the inventor of the cathode ray, with his Rebikoff Chromos underwater camera in foreground

29

Film for Underwater Use

During my early picture-taking efforts, I often tried to save money by cutting corners. I would buy less expensive brands of film, send the exposed film out mail order (often to irresponsible processing laboratories), then commiserate over miscut, misframed, stained, water-marked, poor quality results. Worse yet, those same slides have begun to change color over time. While many are pictures that cannot now be replaced, the originals may not last much longer.

In photography, the old maxim that "you get what you pay for" is quite true. A cheap film stock will never give satisfactory results. Cut-rate processing, while a financial shortcut, will render valuable pictures worthless. While few writers of photography books dare to do more than offer alternatives, experience has shown that there is an incomparable giant for color slide film: Kodak. The best film stock for general underwater use with strobe lights, presently manufactured by Kodak, is 64 ASA Kodachrome. Agfachrome films are almost comparable to Kodachrome in rendering skin tones and reds. For black-and-white photography, though the choice of film here is less important, Ilford and Kodak lead the field for quality films.

For all intents and purposes, Kodachrome film cannot be pushed in processing. Pushing a film means that a film rated at 200 ASA, for example, can be shot at 800 ASA, the compensation being made during processing. In an urgent situation, Kodak's Rochester laboratory can push Kodachrome, but the procedure is very costly. Ektachrome film, which requires a simpler processing procedure, can be pushed.

Kits are available which enable Ektachrome slide film to be processed almost anyplace. This flexibility makes Ektachrome a good teaching film. Films shot on morning dives can be processed that same day and viewed in the afternoon. Ektachrome slide film comes in 64, 160, 200, 400 and specially designed push-process 800/1600 ASA speeds. For most purposes, photographers are better off using the slower speed films. Projection or enlargement of the higher speed slides result in grainy images. Ektachrome yields a pleasing blue quality to underwater pictures, rendering the blues and greens with greater depth and hue.

30

Kodak Ektachrome film is specially designed to provide optimum results when push processed to effective speeds of 800 or 1600, and usable even at 3200 if the need exists.

Color slide film remains the most practical for underwater use. Black-and-white film yields artistic and high-contrast photos of underwater life, but color slides are the only accepted media for most professional uses. Color slides can readily be converted into black and white, and the resulting prints will retain publishable quality. In contrast, black-and-white film is a one-way street. Manipulation of inks during the printing process in magazine use and printing on different color paper can yield interesting effects with black-and-white film, but not color. And, if price is a consideration, at today's commercial rates the only savings to be gained by using black-and-white film result from doing the printing at home. With new Cibachrome process printing, even slides can be developed into beautiful color prints in the amateur's home lab easier than black-and-white printing.

Color negative film is fine for the underwater photographer seeking snapshots to put in an album. Color negatives really have no other use and no commercial publication value. Prints from color slides are more economical in the long run, since the photographer can select the slides to enlarge. Color print film is usually printed by the roll, and it is difficult to examine color print negatives to determine their quality. By using a magnifying loupe, however, a photographer can easily analyze a slide on a light box and make a selection quickly.

31

The choice of film stock is a matter of taste and a function of purpose. One particularly well-equipped underwater photographer I guided over the reefs of Polynesia used color print film exclusively. The man was obviously an accomplished photographer, so I asked him why he used color print as opposed to slide film. In response, he gave me his business card. The man earned his living as a professional photographer, had his own film laboratories in Canada, and said that on vacation he simply enjoys looking at and giving away his pictures. The man had no intention at all of mixing business with pleasure and shunned any idea of using his underwater work commercially. In the end, the photographer made prints that gave his family and friends pleasure, and he enjoyed doing it. Selection of film stock by all photographers should be based on a similar analysis of the purpose of the pictures. If they are for pleasure, that is one consideration; if for publication or projection in a lecture hall, other factors must receive appropriate attention.

Land photographers claim that the slower the film speed, the higher the resolution and the less grain in the picture. The same holds true for films, both movie and still film stock, adapted for underwater photography. Low-light Ektachrome Super Eight color movie film, while a boon to underwater photography, displays a lot of "grain" when projected. This means that the images are not crisp and clear. The larger the image projected, the more the picture seems to fall apart. Kodachrome 25 or 40 Super Eight film holds together better and thus can be projected with better resolution than faster films.

Professional motion picture film is produced by three giants in the industry—Kodak, Fuji and Agfa. Sixteen millimeter color negative film has been refined and improved so that results are excellent. Moreover, the new fast films developed by Fuji, rated at 500 and 320 ASA, are as fast as Kodak Ektachrome reversal movie film. Reversal film means that what you shoot is what you get—you edit the original. Color print film is processed, then a print is made from the negative. The original negative is stored safely away, and the editing work is performed on the print. Both Fuji and Agfa manufacture excellent professional motion picture films in various speeds.

For the amateur's Super Eight movie film, Kodak processing offers the most consistent quality without paying custom lab prices. For

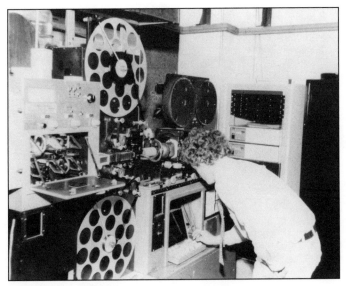

Tim Spitzer of DuArt Film Labs adjusts settings on the color printing machine. Compensation and color balance can be made by a professional film lab during printing.

processing professional 16 mm or 35 mm motion picture film, the giants in the industry are DuArt, TVC and Control Labs in New York City.

Some independent processing labs throw all work into the same chemical soup and cut corners in regeneration steps to save money. Underprocessing, for example, is one way some labs cut costs. Since there is a three-quarter stop-over and about one-and-a-half stop-under exposure tolerance on color film (meaning that there will be a correct exposure if the film was shot within these tolerances), film labs, assuming that the photographer's choice was the correct exposure, underprocess. This results in an overall savings of as much as 10%. While this technique can mean a significant increase in profits considering the volume these processors handle, the results are often less than satisfactory.

Custom photo labs often charge two or three times the price of standard Kodak processing. While this may be necessary for critical work done to professional specifications, such as when a photographer wants film pushed, custom lab work is an unnecessary expense

33

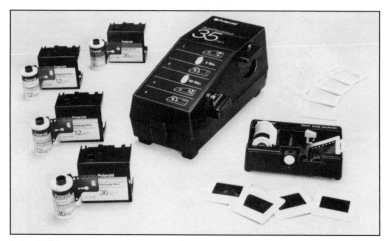

Polaroid 35 mm instant slide system provides convenient on-location proofing.

for most processing jobs.

As a rule of thumb, the slowest speed film that will enable the shutter speed and aperture or lens opening to suit the working requirements and light conditions should be the film chosen. Wide open lens apertures and slow shutter speeds are not ideal for maximizing the depth of field. Some accommodation must be made to obtain the best balance.

Instant slide films must be discussed as a separate category, because the results of this revolutionary Polaroid process are not comparable to normal slide films. The technology is ingenious. Take a roll of pictures in 35 mm, run the roll through the Polaroid processing machine, wait a minute, then cut and mount the slides and project them right away.

The Polaroid color slide film is available in 36-exposure rolls rated at 40 ASA. Their black and white slide films come in 36- and 12-exposure rolls and are rated at 125 and 400 ASA. The film is excellent for teaching underwater photography. Techniques can be tested, equipment tried out, experiments easily and quickly conducted and the results analyzed immediately. Although reds and skin tones are not true to life, the Polaroid instant color slide film yields photographs acceptable for amateur use. In time, Polaroid will improve the film's tonality. The Polaroid black-and-white slides have

amateur as well as professional application, and their instant pro-
jectability is a boon all photographers will appreciate.

Chapter Two

Lenses and Other Hardware

An early impression in photography that marked the formation of my philosophy came in a camera store as I priced a telephoto lens with a rifle grip. The salesman was casual as we discussed the lens. "Well, I don't know," the salesman commented. "I met one of the best candid photographers after his work during World War II. I asked him what lens he used to capture the stark drama in his pictures. He said, 'I just use the standard lens, but I walk up to my subject.' " I did not buy the telephoto lens.

Getting close to the subject is the best way to get good pictures. This philosophy applies more to underwater than to land photography, where back-scatter from suspended particles is not a problem. Moving in close with a standard lens is the key to consistently good underwater pictures. An investment in a variety of expensive auxiliary lenses to avoid pictorial confrontation is not an acceptable alternative.

37

Sixteen Millimeter Movie Camera Lenses

For movie cameras, the 10 mm Switar wide-angle lens was long considered one of the best all-round lenses for filmmaking. A California-based company now manufactures 5.7 mm and 3.5 mm wide-angle lenses that are perfect, when housed behind an optically corrected dome port, for taking films inside shipwrecks or in areas of limited visibility. Zeiss has produced a series of wide-angle lenses with excellent resolution but at a cost that is probably beyond the means of most amateur underwater filmmakers.

The cinematographer's philosophy is to use the widest possible angle with greatest depth of field without deformation of the image. The specialized Rebikoff underwater movie camera, made to U.S. government specifications, is equipped with a 9.5 mm lens. The Rebikoff camera is in focus from about a foot in front of the lens to infinity, even with wide-open aperture settings. This is ideal, for the goal of the filmmaker is to capture movement on film.

The cinematographer must swim into the action or capture the movement as it comes toward the camera. A camera operator is hard-pressed to continually adjust focus as a whale or shark swims into and out of the action. The camera must grind away, and the action must be in focus at varying distances. This makes use of wide-angle lenses mandatory.

Super-Eight Lenses

Many amateur Super Eight millimeter underwater movie cameras have zoom lenses. Some inexpensive housings, however, do not permit adjustment of the lens underwater. If that is the case, the camera lens should be set at its widest angle and, if distance must be pre-set, it should be set at 7 to 10 feet. Most Super Eight movie camera lenses have automatic aperture control, eliminating the need for the photographer to do anything more than point and shoot. Shooting close-ups on film requires a steady camera and through-the-lens viewing to eliminate parallax or misframed subjects.

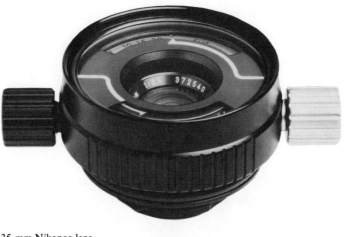

35 mm Nikonos lens

Still Camera Lenses

Nikon manufactures a series of lenses for their underwater cameras. The workhorse Nikonos lens is the 35 mm with a focal range from 2.75 feet (0.8 meters) to infinity. The 35 mm lens has an angle of view of about 43.5 degrees underwater and 62 degrees on land. The camera sees what the eye sees, so estimated or apparent distance is used in setting the lens. The 35 mm lens has an aperture range of from f/2.5 to f/22. The most frequent error made by photographers trying to work close to their subject is to move in too close. Using the 35 mm lens closer than 2.75 feet will result in the picture being out of focus.

When using the standard 35 mm lens, 64 ASA Kodachrome film and the Oceanic 2001 strobe, I set my lens at f/8 to get proper exposures when the subject is 2.75 feet away. The photographer must believe the manufacturer's focal distance tolerances and adhere to them despite the temptation to move the camera closer.

Nikon manufactures an 80 mm telephoto lens for the Nikonos camera. Both the 80 mm and the 35 mm can be used on land as well as underwater. Like most Nikon lenses, the 80 mm is a fine lens, but better suited to land photography than underwater use. The 80 mm has an aperture range of f/4 to f/22. Its focal distance is from 3.5 feet (1 meter) to infinity, with relatively critical focus at closer distances.

80 mm Nikonos lens

As with all telephoto lenses, any camera movement results in blurred pictures. Becasue strobe synchronization with the Nikonos is either at 1/60th of a second with the older cameras or 1/90th with the Nikonos IV and V, there is little tolerance for movement.

Getting the underwater subject properly framed with an 80 mm lens can also be tricky, for the underwater angle of coverage is only about 22 degrees and about 30 degrees on land. The Nikonos 80 mm is an excellent lens for sunsets, portraits or candids from shipboard and can be used with Nikon's underwater macro-photography set to shoot close-ups. A special land-use optical viewfinder is available from Nikon.

An excellent specialized lens for underwater still photography is the Nikon 15 mm wide-angle lens. The lens has an aperture range of from f/2.8 to f/22 and a focal distance from 0.7 feet (0.2 meters) to infinity. The more the lens is stopped down, the greater its depth of field. Using this underwater 15 mm wide-angle lens on the Nikonos

40

camera, I have been able to photograph an entire dolphin whose muzzle was pushed right against the lens. The 15 mm is a corrected dome-port lens, so there is no aberration or distortion at the corners of the picture.

The 15 mm is an expensive lens, and the earlier models are not adapted to the automatic exposure features of the newer Nikonos IV and V underwater cameras. For photographing shipwrecks, large marine animals or divers, the wide angle permits a photographer to work close yet get all of the subject in. At 3 feet, for example, an entire diver will be in frame. This is especially important in murky water or areas of limited visibility. Stopped down, the 15 mm lens allows close-up work with magnificent results, excellent depth of field and a 94 degree underwater angle of view.

Nikon's 28 mm lens, like the 15 mm, is strictly an underwater lens. It is a concave lens with an underwater angle of view of 59 degrees. The 28 mm lens allows the photographer to work closer to the subject, with a focusing range of from 2 feet to infinity. A diver will be in frame with the 28 mm lens at a distance of 5 feet from the camera.

Responding to consumer demand, Nikon developed a 28 mm weatherproof lens for the Nikonos camera. Press or nature photographers working in the rain, boaters and skiers now have a wide-angle lens that will withstand foul weather. The 28 mm weatherproof lens, with a 74 degree picture angle on land, is not designed for underwater use; it is not pressure proof. The lens is graduated for use from 1.5 feet to infinity with an aperture range of f/2.8 to f/22.

Nikon's 20 mm lens has been built to answer the demand for a less expensive underwater wide-angle lens. The 20 mm is strictly an underwater lens with a dome port, like the 15 mm. The 20 mm has a 78 degree picture angle. With control scales on the knobs, this new lens has a distance scale of 0.4 meters to infinity and an aperture scale of f/2.8 to f/22.

At one time a California company, Seacor, manufactured a Sea-Eye 21 mm metal lens for the Nikonos camera. This lens was less expensive than the Nikon 15 mm lens and yielded good results. The lens had an aperture range of from f/3.3 to f/16, an underwater angle of view of 92 degrees and was capable of focusing from 2.5 feet to

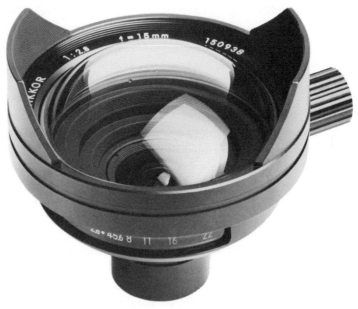

The earlier Nikonos 15 mm lens

infinity. Metal Seacor wide-angle lenses are still in use among underwater photographers. The company also put into production a plastic version of the lens with plastic camera mounts. Many instances of flooding were reported with the plastic version, which costs about $600. The plastic camera mounts wore poorly and never seemed practical, even though the company sold replacements. At last inquiry the remaining Seacor inventory was being sold off and the line discontinued. Many photographers regretted the fact that the metal Sea-Eye 21 mm lens went out of production, for it was at the time a less expensive alternative to Nikon's 15 mm Nikkor underwater lens.

The same company also produced a Super-Eye aluminum housing with a fully corrected dome port. The Super-Eye would enable Nikonos photographers to house a wide-angle or fisheye lens such as the Nikkor 8 mm with an aperture of f/2.8 and a 180 degree angle of view. The Super-Eye dome permitted a 180 degree view, so the 8, 10 or 16 mm Nikkor fisheye lenses could be used with the housing. The

42

External optical viewfinder for earlier 15 mm Nikonos lens

Super-Eye housing mounted the lens inside, and the whole unit fit right on the Nikonos camera.

Other companies have marketed a variety of plastic wide-angle lenses which mount on the Nikonos underwater camera. They are relatively expensive and, although their optical quality may be acceptable, consideration should be given to spending more and getting Nikon quality.

A number of companies, including the Swiss manufacturer Subatec, offer clip-on wide-angle attachments. The Subawider 21 mm clip-on lens, however, creates distortion at the edges of the picture, and there may be small thumbnail black spaces in the corners where the frame is not exposed. Adhesive strips must be pasted on the Nikonos camera's control knobs to insure proper focusing when the Subawider lens is attached. This is an inconvenient drawback, although a few basic settings can be memorized by the photographer who has several cameras or who doesn't want to use the paste-ons.

Aqua-Craft, one of the largest wholesalers of underwater equipment in the U.S., markets a variety of Green Things clip-on wide-angle lenses. They produce the Marine View, which yields a 63 degree underwater angle of view when clipped on the Nikonos 35 mm lens; the Opal Eye, yielding a 95 degree angle of view; and a Fish Eye, which yields 150 degrees when used with the 35 mm Nikonos lens and 160 degrees when clipped over the 28 mm Nikonos lens. Clip-on wide-angle lenses for the Nikonos are alternatives to the more expensive lenses. Since clip-on are certainly not cheap and of limited optical quality, a photographer might be wise to wait until a better

alternative comes along or simply stick with the 28 mm Nikkor lens.

When taking an expensive clip-on lens below, be sure to use strong monofilament line to secure it. I attach the looped end of monofilament to the Nikonos strap ring. The plastic hole on the clip-on lens is usually tiny, and strong monofilament is the best safety line to use. The line should be kept short so it doesn't intrude on the picture.

Fisheye lenses have very limited use. Photos taken with a fisheye lens cannot be used in any quantity in a slide show—their characteristic distortion is gimmicky, and a gimmick is most effective if it is used only once. This limited use may make the fisheye an impractical investment for most amateur photographers.

When asked if I think it is worthwhile for an underwater photographer to buy the Nikkor 15 mm underwater lens, I take out pencil and pad and put down the cost of the lens, its optically corrected viewfinder and the Nikonos body. Then I put down the price of a Nikon F3 or comparable body, motor drive, housing and wide-angle lens. Since the prices are almost comparable when viewed in this manner, the discussion then has to focus on the photographer's needs and practical desires. Housed cameras with interchangeable lenses, corrected ports and through-the-lens viewing are versatile and yield excellent results, but they are bulky in the water and out of the water. Such personal considerations must be resolved by the individual photographer.

When using a wide-angle lens underwater, care must be taken to be sure the strobe does not get in the picture. It is best to hold the strobe well back behind the camera to keep it out of the frame. More unusual problems can sometimes arise. For the longest time I could not figure out what the odd shape was that appeared in some of my underwater pictures. Could it be dust on the inside of the lens? A particle of film stuck inside the camera? It was too consistent from dive site to dive site to be something in the water. I finally discovered the answer. My neoprene glove was torn, and my fingers extended through it. The wide-angle lens had such a large underwater angle of view that it was picking up the edge of my torn glove as my finger triggered the camera. Wide-angle lenses require special care and consideration to ensure that no unwanted objects clutter the picture.

When taking an expensive wide-angle lens underwater, it is a good

Screw-on filter holder which will protect lens threads

idea to leave the lens cover in place. A variety of homemade lens protectors can be improvised by using scrap pieces of neoprene or other protective material. Screw-on plastic or rubber filter holders or

Rubber lens protector for the Nikonos 35 mm lens

lens protectors for the 35, 28 and 80 mm Nikonos lenses protect them from denting and help keep the threads intact so accessories can be used. Lens protectors are inexpensive and well worth the investment.

Unless the damage is severe, a scratch on an underwater lens will not usually affect the lens' optical quality underwater. Lenses may be polished with a variety of substances, including toothpaste. Where substantial scratching occurs, the manufacturer can be consulted for repair or advice as to what material works best to polish the lens. Plastic lenses will probably have to have the dome replaced, but ground glass lenses can usually be polished with felt dipped in linseed oil and then dabbed in rottenstone or pumice. A letter to the manufacturer is the best way to obtain professional guidance concerning lens polishing or restoration.

The screw-on lens cap for the Nikkor 15 mm should be loosened on the boat in order to eliminate the risk of pulling the lens away from the camera and flooding it during underwater removal. Lens caps should be left in place when the camera is not in use in order to protect the lens. No camera or lens should be exposed to direct sun. If it is necessary to leave a camera in the sun, even for a short period, turn it over on some soft object so the lens is pointing downward. Sunlight and heat can loosen elements inside the lens and increase pressure inside the air- and water-tight camera.

Viewfinders

Nikonos underwater cameras have built-in viewfinders. The most recent addition to Nikon's line, the Nikonos V, has a larger viewfinder that denotes the area filled by a 35 mm lens underwater, shooting at infinity. A parallax line on the viewfinder screen allows compensation when shooting at the lens' closest distance of 2.75 feet (0.8 meters). Older Nikonos viewfinder screens are lined off to give the photographer limits for the 35 and 80 mm lenses. These viewfinders are also marked to correct for parallax, thus preventing mistakes in framing the subject when the lenses are used at close distances.

A large variety of plastic "machine gun" type sights or sport finders are sold for use with underwater lenses. They are designed for underwater angles of view, not for land. The photographer that gets

46

into the habit of using the camera's built-in viewfinder will never have to experience the agony of lost or broken external viewfinders or suffer their inaccuracies.

Nikon manufactures an expensive ground-glass optically corrected viewfinder for the 15 mm lens. The viewfinder is handy, but not a must. A photographer, with practice, can effectively frame the subject without using the viewfinder. The newer Nikonos cameras have large viewfinders which make external finders unnecessary.

Many companies, including Ikelite and Dacor, manufacture auxiliary viewfinders for the Nikonos camera. Some of these come with interchangeable screens or masks which show the frame for the

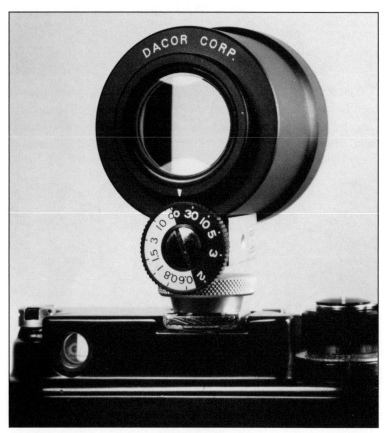

Auxiliary viewfinder mounted on Nikonos II camera

particular lens in use. If the Nikon or other optically corrected viewfinder is used underwater, a safety line (strong monofilament is ideal) should be used to secure it to the camera or lanyard strap. Viewfinders frequently fall off underwater, especially when diving in currents.

Movie cameras have sighting lines and sport finders. Many of the earlier underwater movie cameras also had optically corrected external viewfinders. Most professional underwater film cameras in use today feature through-the-lens viewing—a preferable technique that allows the photographer to see what the lens will record. With practice and discipline, photographers can dispense with viewfinders or sport finders underwater and learn to frame their subjects instinctively.

Housings

Waterproof housings for underwater photographic equipment have been fabricated by enterprising divers for many years. The systems range from heavy-duty plastic bags with special windows to elaborate metal housings for 70 mm Eyemax movie equipment. Cameras in

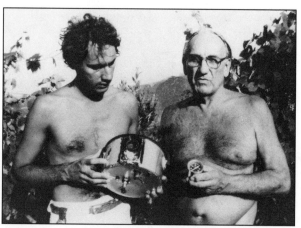

Author (l.) with Dimitri Rebikoff, the inventor of numerous undersea devices. Pictured is his first underwater camera housing, a French "Cocotte-Minute" or pressure cooker with fittings through the pot to house a 16 mm Bolex movie camera.

housings are more versatile than self-contained amphibious cameras, but they are bulky and heavy. Housed cameras remain popular for professional use because they accomodate such features as motor drives, through-the-lens focusing and metering, and an assortment of lenses not available for amphibious cameras.

Deciding whether to buy a housing for one's land camera, as opposed to buying an amphibious camera, is an important decision. It is difficult to sell used housings, whereas used Nikonos cameras are in wide demand and hold their resale value. The choice is a personal one. All of the considerations discussed earlier and hereafter should be thought through carefully before making a commitment to an underwater photo system.

Because it is more difficult to see through the small eyepiece of a housing than through a camera's SLR viewing system, housed cameras are usually fitted with an auxiliary viewfinder, Sportfinder or Action Finder that significantly enlarges the size of the viewing port. With the Nikon finder, this viewing area is about 1″ x 1¼″.

Oceanic Products has manufactured a cast aluminum housing for Nikon and Canon cameras for many years. The housing is sturdy and reliable and comes with interchangeable ports and various control knobs. Aluminum housings offer the advantage of durability, although they are heavy to transport. The weight of a metal housing in water, however, is beneficial—plastic housings are usually buoyant and must be equipped with weights or weighted handles to keep them from floating.

Plastic housings are versatile, lightweight and permit the photographer to readily see the camera controls and indicators. Leaks can be detected immediately with a clear plastic housing, although the results, unfortunately, are the same. Plastic housings, fully equipped with controls and dome ports, will cost about half as much as their metal counterparts. Plastic is more fragile, however, and tends to scratch. Land strobes can be housed in plastic or metal housings.

The cost of these housings makes it important for one to carefully consider the options before buying. Housings are available with a variety of frontports. Like the Nikonos 35 mm and 80 mm lenses with flat glass for the outside lens element, flat ports can be used on housings. Wide-angle lenses, shot through flat ports, will show

distortion. This is why the Nikonos 15 mm and 20 mm lenses have dome ports for their outside lens element and the Nikonos 28 mm lens is concave.

Because of the reflection of light passing first through water and then the port and lens, objects appear larger and closer. The angle of acceptance of a lens underwater is less than in air. A 50 mm standard lens for a 35 mm camera may have a 46 degree angle of view on the surface, but this angle is reduced to only 34.5 degrees when the lens is housed behind a flat port. (25% of 46 degrees is 11.5; 46 - 11.5 = 34.5 degrees.) This means that the photographer will have to move back farther from the subject to get it all in. Refraction causes objects to appear 25% closer, so the photographer will have to move back 25% of the distance.

Wide-angle lenses shot through flat ports show distortion at the edges of the picture. This is called peripheral distortion since the light rays are bent or distorted at the edges or periphery of the frame. Distortion at the edges of the frame breaks up the color spectrum of entering light. Chromatic or color aberration occurs when wide-angle lenses are shot through flat ports.

Distortion can be corrected by fitting the housing or underwater wide-angle lens with a dome or egg-shaped glass or plastic port. Specialized optical glass ports for the fabrication of homemade underwater housings are not only difficult to find but are also very expensive. Ports that serve just as well can be obtained from marine compass makers. Since compass domes are not sold for the specialized photography market, they are relatively inexpensive. Light enters the dome port without bending, so distortion is absent.

Care must be taken both on the surface and underwater to protect the dome port from being damaged or scratched. A large piece of neoprene over the dome when not in use is a good precaution.

Movie camera housings for specialized professional equipment can be very expensive. The housing made for the Arriflex 16 mm movie camera, for example, costs about $8,000. Custom housings for video cameras and recorders are also costly. Various devices are available for camera housings that produce an audio or visual signal when water enters the housing. This may give the photographer time to get the housing to the surface before greater harm is done. Small silica gel

Filmmaker Christian Petron with the most advanced underwater film camera ever designed. It is a compact 35 mm Rebikoff camera used where wide-screen theatrical projection is necessary. Price? About $60,000!

packets like those that are packed with new camera equipment can be placed or taped inside the housing to help prevent moisture from forming.

If one is taking a housing on a flight where the pressure gradient will be less than surface pressure, steps must be taken to ensure that increased pressure inside the housing will do no damage. Removing the outside port or "O" ring seal is one way to avoid the problem.

"O" rings on housings must be given special care and attention. They must be checked for dirt or sand and carefully greased. When sealing a large housing, pressure should be applied evenly on opposite sides of the housing, snapping opposite clamps in place together to insure proper seating of the "O" ring.

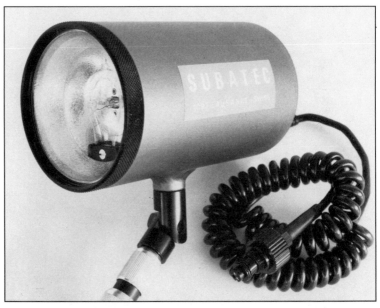

The non-interchangeable strobe-to-camera connector; it cannot be unplugged underwater.

Connectors, Brackets and Arms

Wires that connect the electronic flash to the camera underwater must be durable and waterproof. Where the connector cord is fitted to a bulkhead, an "O" ring seal must be used to ensure watertight integrity. The contact end of the strobe cord is generally screwed into the camera synch socket, which is kept waterproof by another rubber "O" ring. The advent of connectors that maintain their waterproof seals in both camera and strobe, but which can be disconnected underwater, now enables photographers to use more than one camera without the burden of taking two strobes below.

One popular connector that can be disconnected underwater is the Electro Oceanics (EO) connector. The EO connector system, marketed by Oceanic Products and others, is made in two parts: a strobe-synch adapter plug that screws into the Nikonos socket or is mounted through a housing in the form of a bulkhead connector; and a male plug that forms the end of the strobe cord. The male plug consists

52

The male plug of the EO connector system

of a rubber prong bearing two copper bands spaced about 7 mm apart. The female plug, extending from the adapter screwed into the camera, has internal parts that make contact with the two copper bands when the EO male plug is inserted. The EO connector system is a reliable method of switching the strobe from camera to camera underwater, thus enabling the photographer to take wide-angle or close-up shots on the same dive.

It is a good idea to put a small amount of silicone grease in the female EO plug prior to each dive. This facilitates insertion without the use of too much force. EO connectors should be gently twisted together, not jammed in and violently pulled out. Corrosion can be removed from the plugs by soaking them in vinegar for a short time, then washing them in fresh water.

Nikon has changed the internal Nikonos strobe synchronization sockets over several years of manufacture. The Nikonos I and II models require a post and bar adapter to make contact with the internal parts of the camera. The Nikonos III, IV and V have prongs

53

which plug into holes in the adapter.

Ikelite and Sea Research and Development manufacture removable underwater connector systems with screw-on collars. The adapter plug is screwed into the Nikonos camera or fitted on the bulkhead of the housing. Male plugs at the end of the strobe cord are inserted into the female adapter receptacle, and the screw-on collar is tightened. When using the connector systems, it is a good idea to put silicone or "O"-ring grease on the adapter threads before the plug is screwed into the Nikonos camera. This will ensure easy removal.

When the adapter plug is screwed into the camera, it must be done carefully so only the external screw-in collar turns. Twisting the connector portion will damage the socket and connector parts inside the camera. Adapters that have been improperly screwed down, especially in those cases where they must be placed through a bracket upon which the camera is mounted, account for frequent floodings. The threads must mesh properly, and the adapter must be screwed in smoothly all the way. This is not an easy maneuver when the camera has to be held in place on its bracket or tray and the adapter screwed down through it.

The threads of the Nikonos socket are relatively fragile and may become damaged with use. While Nikon will make this repair, a machinist, Elwyn Gates of Gates Underwater Products in San Diego, California, specializes in refitting the Nikonos base plug and makes the repair professionally at a lower cost.

No water should ever touch the adapter parts. This will cause shorting and malfunctioning of the system. The camera should be soaked in fresh water, rinsed and dried before the adapter is unscrewed. Corrosion will occur, and it will be difficult to remove adapters from the Nikonos if they are left in the camera after protracted use in salt water. Adapters should be unscrewed and cleaned and the "O" ring and threads re-greased at the end of each day's shooting.

Sea and Sea manufactures a connector system called the Sea Loc fitting. The Sea Loc can be plugged into the Hanimex underwater camera, marketed by Sea and Sea under the trade name Pocket Marine. Sea and Sea's Sea Loc underwater connector consists of two metal probes extending from a rubber plug, received by a female

54

bulkhead fitting. Sea Loc connectors are also available for other camera and strobe adaptations.

An underwater photographer should choose the connector system that will be versatile enough to suit present and predicted needs. A strobe connector that cannot be unplugged underwater relegates the strobe to one camera. The EO connector system for the Nikonos or the EO bulkhead fitting for housed cameras is versatile and reliable. A photographer can dive with a housed Nikon F3 and a Nikonos or two or three Nikonos camera, increasing not only the lens possibilities but the number of pictures that can be taken during a dive.

The way a camera, strobe and light meter are joined together underwater can be as versatile as one's requirements dictate. The freedom of a handheld meter, camera and strobe with resultant ease of manipulation is counterbalanced by the inconvenience of having the equipment loose in the water. Trays or bars upon which the camera is mounted have a variety of systems to accommodate the strobe arm and light meter. With ingenuity, two strobes can be mounted on the same tray. Trays or bars to accommodate Nikonos cameras are available from a number of manufacturers dealing with the popular market.

Oceanic Products makes a universal shoe for use on a camera tray or housing. The shoe enables their strobe arm to slide on and off, with a knob to secure the arm in place. Subsea Products makes a push-button strobe mount which allows the arm to slide off. Handing

Camera tray showing handle-grip shoe; above is trigger thumb-release for camera

Subsea equipment down into the water or back into the boat must be done with care—touching the button accidentally will cause the strobe arm to disconnect. Subatec in Switzerland manufactures a convenient bracket and telescopic arm for their strobe systems. Butterfuly clamps, knobs and wing nuts are also popular ways of attaching strobe arms to housings or camera trays.

The arms themselves should be flexible and long enough to distance the strobe from the subject and allow for creative lighting. Oceanic Products make ball joint arms in three lengths—15, 21 and 28 inches. The arms come in two sections connected together by a system of two balls on a maneuverable bracket. In addition to being versatile, the Oceanic arms are strong enough to hold the strobe in almost any desired position underwater.

Hydro Photo manufactures a highly versatile strobe arm called the Cobra. The Cobra arm consists of six 85-mm-long tubes. Each tube is separated by a ball. A flexible steel cable runs through the middle. Turning a knob tightens the cable and holds the Cobra arm in the

Oceanic balljoint arms come in three lengths; they are both versatile and strong.

desired position. The arm is quite flexible because of the number of ball joints between the tubes.

The choice of brackets and arms, or their use at all, is not something a beginning photographer must decide initially. A light meter with lanyard around a diver's neck may enable more flexible readings than if it were bracketed in a holder and attached to a camera tray.

Once the Nikonos camera is put on a tray, some photographers use a thumb-release lever to simplify triggering the camera. The thumb release acts as a lever and, as such, puts more tension on the Nikonos shutter release than would a human finger. It is also more difficult to judge the power being used when a trigger is attached. Using a trigger can result in expensive camera shutter-release repairs if extreme care is not used. It is better to use a finger on shutter-release mechanisms to avoid forcing controls and also to know when the roll of film has been fully exposed.

Care must be taken with connector cords so they are not bent at extreme angles or twisted in use or transport. The cords are fragile, and internal breaks will result in misfires. Strobes and cameras should never be handed into or out of the water by their cords.

Chapter Three

Let There Be Light!

The very word photography implicates light as the single most important feature of the craft. If the subject is not properly lit, the photographer cannot achieve a primary goal—to capture the salient features of the subject for the viewer. Achieving this most basic goal underwater is complicated by the novel conditions that man, a land animal, must understand and adjust to when entering the unique environment of the marine world.

Light and Light Measurement

Water has the same effect as a cyan filter. The density of water cuts down the amount of light that penetrates beneath the surface layer and lends a blue or blue-green tint to pictures taken with natural light.

Color perception is lost rapidly as one descends underwater. Depending on brightness, water clarity and the angle of sunlight penetration, everything appears blue or blue-green at depth. (Beginning divers are often told that if they accidentally cut their finger underwater, they will see that blue blood actually flows in their veins.)

Selenium light meter

Warm colors are lost first. Reds and oranges are not perceived by the naked eye or on film at depths beginning at about 10 to 15 feet. In tropical water where the sunlight is strong overhead, one may perceive reds at greater depths than in cold murky water or where there is subdued light. Yellow persists in tropical waters, often to depths of about 45 to 60 feet, again depending on light conditions.

This loss of color perception is not a startling revelation. Anyone awakened in the middle of the night, seeking out familiar landmarks, has experienced color blackout. Everything appears gray or black and white until the switch is found and the lights reveal the colors in the room and fixtures. Colors are not absent in the ocean depths; they are just not perceived with the naked eye. A diver's flashlight will quickly reveal the original bright reds and oranges of life underwater.

The photographer working in a setting of natural light can be rewarded with pleasing and often spectacular photographs, but conscious attention must be paid to color balance and lighting or the pictures will be quite flat and disappointing. A diver measures light underwater in much the same way a photographer meters light

topside. The light meter is simply housed in a watertight case.

Light meters are of two general types: the Selenium photoelectric cell or the Cadmium Sulfide cell (CdS). The Selenium meter, when activated by light, produces an electric current which is read off a needle indicator wired to the cell. This photoelectric cell has a limited life span. The Selenium meter is less expensive than the CdS, but it will eventually stop working and will have to be thrown away. The Cadmium Sulfide cell is battery operated. A resistor inside the CdS cell is affected by the amount of light that strikes it. When there is no light, the resistor is capable of blocking the electric current from the battery.*

Light meters intended for underwater use can simply be encased in a waterproof box. Controls are worked through "O" ring sealed ports. A number of companies manufacture plastic cases for this purpose. Specially designed marine meters in their own self-contained plastic shells are also available on the market. These self-contained meters, while more expensive than the housed variety, are well worth considering as a first purchase rather than the less expensive photoelectric cell or housed meter.

The Sekonic CdS self-contained underwater light meter is easy to use underwater. This meter has a large read-out scale, and the film-speed indicator can be changed without taking the meter out of a plastic case. Danger of flooding is minimized by the integrity of the meter shell. The Sekonic underwater meter is made with a higher degree of skill and care than less expensive varieties currently on the market. Oceanic Products of California also manufactures a highly regarded self-contained underwater light meter that is beginning to gain wide acceptance among both professional and amateur under-water photographers. The Oceanic meter is of the photoelectric design, but is solid and more durable than housed counterparts.

Accurate light measurement is important. A hasty meter reading underwater, like a hasty meter reading on land, will yield an incorrect exposure. Rarely do professional photographers take one static meter reading. A pro works quickly, practiced eyes gauging several meter readings in order to judge light balance. A camera setting is selected that will most closely resemble the light composition the photographer reads off the meter. This procedure is called "averaging."

* See color section. 61

Novice underwater photographers are often seen with static camera set-ups. They dive with everything—camera, strobe, light meter—attached to a metal bar or bracket. The novice then proceeds to take pictures as though driving a car. Everything that is straight ahead and falls within the flat light of the headlights will be filmed.

Static pictures are dull, the results often uninteresting. Subject light is poor because of the way the equipment is arranged on a bar or bracket. The light meter fixed in a meter holder and screwed onto the handle does not lend itself to averaging. In contrast, a handheld meter can be used effectively to gauge the light and select a reading for the emphasis and composition desired. Shadows falling on the subject, objects or marine life concealed under coral, and side-lighted subjects are prevalent underwater. Versatile use of a light meter is necessary to obtain the best exposure.

As on land, through-the-lens metering and automatic exposure techniques are possible underwater. But there are drawbacks to both systems. Through-the-lens metering underwater with a housed single-lens reflex (SLR) camera presents problems. Even with a specially adapted viewfinder, it is difficult to read needles inside the camera through the housing eye port, then through the camera. This would be almost impossible during a night dive, even with the sport finder attachments made for Nikon and Canon cameras. No self-contained underwater SLR camera has yet been manufactured commercially, although research and development by major manufacturers continues and an amphibious underwater SLR will be available in the future.

Automatic-exposure cameras in housings are fairly popular. They generally give good results, yielding pleasant souvenirs of a diving vacation. Some models are self-contained and some are spring-wound or self-winding. The spring-wound Ricoh Marine camera in its round plastic housing has been quite popular among sport divers, who can fire off picture after picture until about twenty exposures are made and the spring must be re-wound.

I have made effective use of the Ricoh Marine camera in its housing to introduce students to simple underwater photo techniques. The electric eye built into the camera sensed the ambient light conditions and automatically set the aperture. Side-lighted, back-lighted, or

62

subjects on sand or under coral could not be individually metered, and thus many exposures were over- or underexposed. On the whole, however, the snapshots pleased the divers, who were glad to have souvenirs of their trip.

The newer Nikonos underwater cameras have built-in light metering systems and automatic features. The photographer can obtain a through-the-lens exposure reading and use the camera's automatic exposure features. A lens opening is pre-selected and the camera's built-in light meter judges the natural light, automatically selecting the proper shutter speed. A red display light inside the camera viewing system will signal if there is too little or too much light for the aperture selected. The newer Nikonos models have automatic coupling for Nikon's underwater strobes.

Proper light measurement underwater is accomplished by determining the center of interest in the picture, as well as the angle the photographer wishes to use to best capture and frame the subject. Film speed is plugged into the light meter, so the photographer need only pre-select the shutter speed. On some of the larger self-contained meters, the photographer can read the aperture or lens opening right off the needle.

Light is gauged by taking two or three meter readings at various points within the frame. If there is light variance within the framed subject, then the photographer may wish to average his reading, selecting an aperture or lens opening between the two readings. Another technique would be to bracket the shot. The photographer takes two, three or four exposures of the same subject from ½ to 1 stop over and under the reading, as well as the actual reading.

A question frequently asked is whether a light meter is required for those using underwater strobes or artificial light. If the dive is at night or deep enough so that ambient or surrounding light is insignificant, then a light meter is of no value. If one is doing shallow tropical diving in ample ambient light (where the strobe is being used to bring out the intensity of color or to eliminate shadows), or if the subject of the photograph is on sand or other reflective area underwater, the natural light may be brighter than the underwater guide number of the strobe. For example, a correct aperture selection using the strobe alone may be f/5.6. The light meter reading over a sandy bottom in shallow water

may require f/8 or f/11. If one were to use a strobe with its guide number alone, without taking into account the ambient light, the picture would be overexposed.

Where there is intense ambient light, my technique is to stop down to the smallest lens opening indicated by either the strobe guide number or the light meter. If time and conditions permit, I bracket the exposure from ½ to 1 f stop over and under the reading.

Using an underwater strobe, even when there seems to be ample ambient light, brings out the intensity and brilliance of colors. A strobe develops contrast, often lost in underwater pictures taken with natural light. The imaginative use of strobe lighting can produce effective combinations, even in bright shallow water. Color can be highlighted in the foreground with a strobe, while divers further away appear in natural light. Contre-jour poses against the sunlight also yield pleasing photos.

Metering ambient light to account for divers at some distance, then regulating the lens opening to take into account a proper exposure for the subject in the foreground, requires some experimentation. If the lens is opened too wide, the subject matter near the strobe will be "burned out" or overexposed. It is thus preferable to set the camera lens opening to properly expose the material nearest the strobe.*

Occasionally special effects are desired, and a photographer will want to take a picture of the surface and underwater in the same frame. Such a picture could involve the dive boat and divers underwater or a diver standing with head and torso out of the water and feet underwater. Since a photograph properly exposed for the denser water will result in an overexposure on the surface, compensating filters must be used on the portion of the lens out of the water. Conversely, if a flash or strobe is to be used underwater, the topside portion could possibly be underexposed.

Some underwater photographers have solved this problem by building a weighted box. A land camera using a dual lens Rolleiflex is inserted in the box. The glass is filtered with insert filters that slide in and out of the viewing port. The picture is taken through a glass port in the box, which floats half in and half out of the water and is dry on the inside to protect the land camera. The same effect can be achieved by hand-holding the camera half out and half under the water and using

* See color section.

diopter filters on one half of the lens. Such creative use of a camera that is properly exposed using light-balancing techniques can produce imaginative results.

Flash Meters

If a photographer can be sure the exposure is correct before snapping the picture, film will be saved and photographs will be of consistent quality. No studio photographer or professional using artificial lighting, fill lighting or flash, snaps a picture without reliance on a flash meter. The Minolta Corporation has been building professional flash meters to the highest specifications for years. The Minolta Flash Meter III is an electronic wizard that can be used to measure ambient light, take ambient light into account when a flash is used, measure flash output alone, or judge the exposure index of any given flash.

The Minolta Flash Meter III is handheld or tripod-mounted where the subject is to be photographed. The proper mode is selected on the digital read-out scale, and film speed and shutter speed are set on the meter. The flash is then triggered and the resultant information used to set the camera. The Minolta flash meter further simplifies the procedure by holding the reading. The exposure is set according to the aperture or lens opening indicated on the digital read-out, or the next closest opening.

Confused by claims of flash power made by various underwater strobe manufacturers, consumers can easily test a strobe by measuring off various distances and recording the aperture readings. Dividing the results by the water filter factor (3.5 is usually used) will provide the underwater guide number of the flash. In a plastic housing, the Minolta flash meter can serve as an ambient light meter and gauge the proper setting of the camera underwater, taking into account ambient light and strobe output. Selective use of the flash meter will enable a photographer to assign realistic and dependable values to a particular strobe. These values can be compared with the manufacturer's specifications and extrapolated for use underwater. Using the Minolta Flash Meter III to test a particular manufacturer's underwater strobe, I found that the given aperture settings provided by the

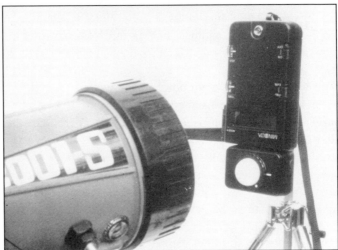

The Minolta Flash Meter III can be handheld or tripod-mounted.

factory for the strobe were off by at least one stop.

Those photographers unwilling to invest in a flash meter may have some luck borrowing one from a professional photographer. Or, with the cooperation of the sales person, a couple of quick tests may be run in the camera store where you buy your film and equipment. The Minolta flash meter is a professional tool that takes the trickery and chance out of photography, certainly a wise investment for any serious photographer or filmmaker.

Artificial Light

A very early black-and-white underwater movie depicting a shipwreck off Marseille, France, took advantage of natural light and the tempo of fishing nets caught on the vessel's superstructure. Famed underwater pioneer Philippe Tailliez swam over the wreck, framed against the net-shrouded masts and rigging. The film was dramatic and focused attention on its makers, Philippe Tailliez and Jacques Cousteau.

Compact and dependable underwater movie lights and strobe lights are readily available on today's market and are within the price range of amateurs as well as professionals. Not every photographic opportunity, however, requires the use of artificial light. Magnificent underwater scenes can be captured without the use of lights or strobes, as the early shipwreck film demonstrated.* Imagination and an eye for composition will suggest many natural light photographs under conditions that do not lend themselves to the use of artificial lights.

An experienced senior editor at one of the nation's leading art book publishers, while reviewing a selection of shipwreck slides, commented that they were too blue. The criticism serves as a reminder that the use of strobes or lights should be limited to a maximum distance of about 6 to 7 feet (2 meters) from the subject. The density of the water cuts down effective use of light at greater distances. Thus, pictures like those of the shipwrecks, taken at distance, will have a blue cast. The use of slave strobes or remote auxiliary lights will permit spotlighting of more distant subjects. As a rule of thumb, however, strobes and lights are not effective except at close range.

Movie lights can be fabricated from sealed beams wired together

* See color section.

and cast in a mold of waterproof epoxy. A generator on shipboard supplies the lights with current. While they are powerful and effective, the lights require a cable tender and necessitate transporting bulky generators and cables. More practical but less powerful are self-contained movie lights powered by rechargeable ni-cad batteries. Ni-cad powered movie lights, while easy to transport and mount on the movie camera housing, have a short burn time. The batteries last from about 6 to 24 minutes. Amateur movie makers will choose their lights based on cost and practicality. Since most amateurs work with 50-foot or at most 100-foot rolls of film, the short burn times of the self-contained battery-powered movie lights is not a great drawback.

Movie lights can be used to light the subject in still photography. Some filtration may be required, however, since the movie lights do not produce the same color balance as strobes. Movie lights have a different Kelvin or color temperature rating than electronic strobes. A picture taken with movie lights may appear too orange or yellow when lights with low (5200 K) Kelvin ratings are used. Sunlight has a 6000 K rating, and most strobes try to approximate its white light rating to obtain proper balance with color slide film.

Strobes for use in underwater photography have proliferated to keep pace with the expanding market and popular demand. Regardless of its size, shape or color, a strobe is simply a flash tube with a triggering mechanism equipped with a battery in which power is stored and boosted by a capacitor. When the capacitor is charged and the strobe is ready to fire, a small light goes on to signal the photographer that the strobe is ready for use. Strobes are powered by batteries, ranging from simple disposable penlight cells to rechargeable nickel-cadmium power cells.

When choosing an underwater strobe, one of the first considerations should be its intended use. A small disposable battery-operated strobe may be ideal for close-ups and fill lighting. It is light and small, easy to transport, and the batteries can be removed for long storage. On trips or bivouacs away from power sources, extra batteries can be taken along to replace worn-out cells. If a strobe receives heavy use, rechargeable batteries can result in significant savings. Rechargeable power cells are also available and are quite popular among photographers who go through a lot of batteries.

Machinist works on one of the dies designed for the molding process of Subsea underwater strobes.

The high grade resin is drawn from a supply barrel. It is clear and colors must be added to make the desired housing.

The resin is mixed and color added.

A glass globe is placed over the resin and the air inside is evacuated to draw bubbles out of it.

The mold is prepared for the Subsea 150 underwater strobe.

The resin is poured into the molds for the strobe housings and various parts.

The resin is placed in an oven to bake, which will aid the
hardening process.

Larry Salvo, head of Graflex-Subsea Company,
removing some of the molded housings and parts

Larry Salvo with the molded front ports for the Subsea
150 strobes. In the background is a molded housing.

There is nothing mysterious about an underwater strobe. Here is a
view of an open Subsea 150 unit and beside it the main component parts, a
capacitor to store the charge, the transistorized circuit
board and the switch.

The components of the underwater strobe in close-up, the
capacitor (round) which stores the charge, the
transistorized circuit board and the switch that is
hooked up internally with an outside water-tight fitting
to fire the strobe (wires from it).

Subsea 150 strobe being assembled in the Graflex-
Subsea factory in Florida.

Graflex-Subsea technician assembling a Subsea strobe
at the electronics bench in their factory.

74

Larry Salvo, head of the Subsea company,
pressure testing finished and assembled
Subsea underwater strobes before
they are shipped out to customers.
The test insures the water-tight integrity
of the units.

Some strobes, including the Subatec electronic strobe, offer the choice of disposable battery operation, a power-pack option with a rechargeable unit, and a solar-powered recharging panel. Ni-cad batteries are probably most practical in the long run for the underwater photographer, both in terms of cost and dependability for regular current output. Ni-cad batteries must be kept charged. If ni-cads are to be stored for any length of time, a routine charging schedule should be followed. *(See Warning, page 87.)

The capacitor boosts and stores the batteries' power. A capacitor can produce a deadly electrical shock. Manufacturer's instructions should be followed explicitly. Never attempt to make homemade repairs of flash equipment!

Some strobes, like the Subsea models, use high-voltage photographic batteries which are disposable. These 510-volt or similar batteries are like those used by wedding and news photographers in

Subatec strobe with its multi-power settings to adjust flash output

75

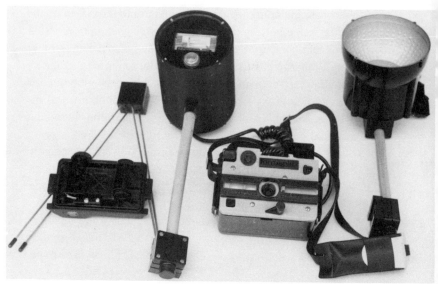

Formaplex camera with flashbulb holder (right) and small housed strobe light. These units are modestly priced for those not ready to invest in the Nikonos camera.

settings where a short recycle time is necessary. High-voltage photographic flash batteries are fairly expensive and have a short shelf life. They are difficult to buy fresh since they are not routinely stocked except by major suppliers. Replacement of high-voltage batteries must be approached with care because of the danger of electrical shock.

Ni-cad batteries are used in the more powerful and popular Oceanic strobes. Their charge time is only about 4 hours, and they recycle in about 6 seconds. Although 6 seconds can seem like an eternity when a shark or whale is swimming by, certain trade-offs are necessary when the photographer is trying to choose the best strobe for its intended use.

When ni-cad batteries are stored for any length of time, they may be sluggish. The capacitor may have to be reformed to get the strobe unit back into peak operating condition. Forming the capacitor is accomplished by charging the strobe for the rated length of time, firing it off slowly until the unit is discharged, then charging it again. A ni-cad battery that has been allowed to fully discharge and then sit on a shelf

76

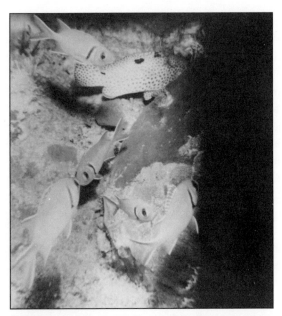

Example of out-of-synch strobe shot using faster shutter
speed than indicated

for a long period may be beyond hope of rejuvenation. In the case of
strobes, the more they are used, the more they remain at peak
operating condition.

Strobe lights must synchronize with the camera. Flashbulbs have a
relatively long burn time; shutter speed can be synchronized with
flash bulbs at 1/125th of a second or higher shutter speeds, depending
on the bulbs. A strobe fires rapidly. For the film to be properly
exposed, the strobe must light the subject when the camera's shutter is
maximally opened. The older Nikonos I, II and III models with their
focal plane shutters synchronize with electronic flash at shutter
speeds of 1/60th of a second; the shutter speed for the newer Nikonos
models is 1/90th of a second.

Ratings used by underwater strobe manufacturers may be
confusing. Ratings are often given in imprecise terms, making it
difficult for a comparison shopper to choose between them. A strobe's
guide number in air must be divided by the water filter factor
(approximately 3.5) to obtain its underwater guide number. An

77

underwater guide number can be meaningless. Small, narrow-beam land strobes in housings, for example, may have a high underwater guide number. Housed land strobes have a small underwater angle of coverage and thus are less effective than an underwater strobe with a smaller guide number but wider beam angle.

The angle of coverage of a strobe is important. When choosing a strobe, the photographer should consider the angle of view of the lenses to be used with the camera. A 15 mm underwater Nikkor lens requires a strobe which covers an angle of at least 94 degrees underwater if the entire frame is to be filled with light. Thus, when rating underwater strobes, the angle of coverage must be considered in conjunction with their underwater guide number.

Every roll of Kodak film comes with a manufacturer's rating chart giving information about the film for correct exposures. The chart lists flash bulbs and indicates their guide numbers at different synchronizations. The chart also recommends filters that will give correct color balance when photolamps or tungsten lighting are used. In addition, the film information chart gives a series of ratings for the electronic flash.

The electronic flash ratings found on the film information sheet plot the BCPS (Beam Candlepower Seconds) ratings of the strobe against the guide number of the film. With 64 ASA Kodachrome film, the land guide number for a strobe rated at 2,000 BCPS is 80. To obtain proper f-number or aperture settings, the photographer must divide the guide number by subject-to-strobe distance in feet. If the strobe is rated for a guide number of 80 and the subject is 10 feet away, the aperture should be set at f/8 and the strobe synchronized at 1/60th of a second.

To obtain the strobe's underwater guide number for a particular film, divide the surface guide number by 3.5. This takes into account the density of the water medium and is an approximation for most tropical sea water. The underwater guide number for the 2,000 BCPS strobe using 64 ASA Kodachrome film would be 80 divided by 3.5, or 23. If the strobe to subject distance is 10 feet underwater, then at 1/60th of a second the aperture setting should be f/2.3, rounded off to f/2.5. Knowing the BCPS rating enables a photographer to determine the strobe guide number for any given film stock.

78

Guide numbers, including the 3.5 water filter factor, are approximate. Bracketing and experimentation are required to obtain correct exposures. Many underwater strobe manufacturers provide underwater guide numbers for their strobes with various film speeds. Some provide decals which can be affixed to the strobe for ready reference underwater. By noting camera settings and studying the results, keeping in mind that manufacturer guide numbers are approximations, the photographer should be able to work out optimum guidelines.

Manufacturers who rate their strobes in watt-seconds are only rating the strobe's stored capacitor charge. This is rather meaningless for an underwater flash unit, because the angle of coverage, the size and shape of the flash reflector and other considerations determine the strobe's overall effectiveness, not its electrical power rating or its underwater guide number alone.

Another consideration in choosing a strobe for underwater use is its versatility. Some photographers prefer to house their land strobes rather than spend money for a specialized underwater flash. The increasing cost of housings and connectors, when compared to the relatively inexpensive underwater strobes on the market today, are making this alternative less practical than it once was. Housed land strobes provide a narrow beam of light underwater, although a diffuser over the flash tube can be used to increase the angle of coverage.

Many strobe manufacturers have developed automatic sensors for their units. The sensors, called Strobo-eyes by one manufacturer, measure ambient light and automatically adjust the output of the strobe. Oceanic Products manufactures a self-contained submersible automatic strobe with a remote sensing eye. The strobe automatically compensates when used in areas of bright ambient light. While some photographers depend on this system, it is a costly option. An underwater photographer using a light meter to gauge ambient light in shallow water can accomplish the same goal. Moreover, automatic sensors can be fooled by shadows. A photographer will often get consistently better picture by depending on discipline and experience in the use of the basic strobe and camera equipment.

Nikon markets a through-the-lens flash control with its new Nikonos V camera. The camera's automatic features control the flash

79

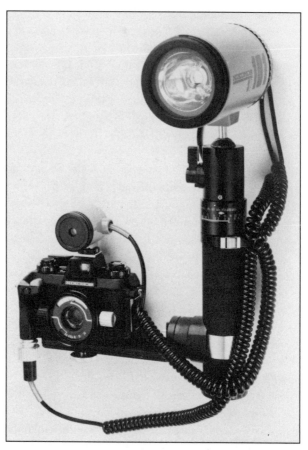

An older Nikonos IV camera with its strobe equipped with an auto-sensor mounted on camera

output by means of a light sensor which reads the flash off the film frame through the lens as the picture is exposed. The unit also takes into account strobe and ambient light with automatic and manual features, permitting the photographer to override the automatic system if desired.

Divers buying new underwater photo equipment are best advised to stay away from flashbulbs. They are the bane of the underwater photographer. Flash contacts do not work reliably, they are expensive and bulky to transport, they are inconvenient to work with under-

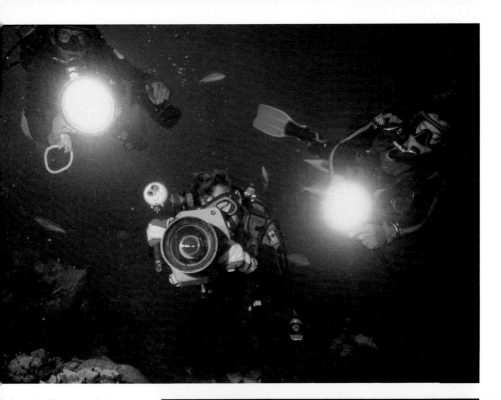

nderwater filmmaker John
oneman flanked by light
ndlers while filming on location
 Bonaire

Magnificent underwater scenes
n be captured without the use of
artificial light.

Sekonic light meter mounted on John Stoneman's Arri-Marine motion picture housing

A colorful example of commens behavior comes from a close-up of t clownfish swimming among t stinging tentacles of a sea anemor

baby trumpetfish rests on a piece of coral—the use of mimicry to avoid predation is one of many interesting imal behaviors that can be captured on film.

Set the camera lens opening to properly expose the material nearest the strobe. Here foreground strobe illumination was used up the shipwreck's ladder; natural light takes over in the blue background.

Pursuing animals underwater can result in tail shots

Waiting for a fish to turn three-quarters will result in a more pleasing photograph.

Composition—setting up a picture so it looks good—often involves chance encounters, such as these dolphins caught in a sunburst.

Divers with lights in hand yield dramatic results in photographs.

Night diving presents unique underwater settings for the photographer.

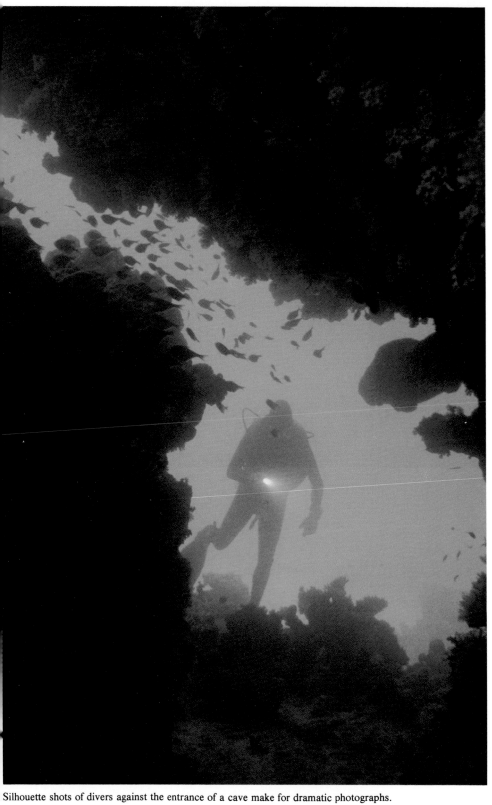
Silhouette shots of divers against the entrance of a cave make for dramatic photographs.

Colorful wetsuits have
added brightness and fashion to
underwater photography.

With their bright colors and
frills, nudibranches make
magnificent macro subjects

water, and they litter. Underwater photographers who have begun with flashbulbs quickly outgrow them. It is better to buy an electronic underwater flash initially than to find out later that flashbulbs are just not suited to one's needs.

Flashbulb units are just as expensive today as electronic strobes. Brightness and increased burn time of bulbs, allowing shutter synchronization at 1/125th of a second or higher with some focal plane flash bulbs, rarely compensate for their unreliability and inconvenience. Nikon, however, has made a flashbulb holder for years for their underwater cameras, and some divers still use them. Underwater, flashbulb photographers generally prefer clear bulbs to blue ones for distance shots. Clear bulbs emphasize warm colors, reds and skin tones. When shooting at distances closer than about 6 feet, blue flash bulbs offer a more natural rendering of red and skin tones. At close range, clear bulbs lend an artificial cast to warmer colors.

Photographers with units that use bulbs must remember to take care

The backscatter in this picture was caused by reflection from suspended particles in the water.

in removing the bulbs from the reflector. When working underwater, it is sometimes difficult to get the bulbs out. Use of too much force can result in a broken flashbulb and a cut hand. Sandpapering the contacts before taking the flashbulbs underwater will increase their reliability, but not much. It is wiser to avoid them from the beginning.

Using artificial light creatively underwater is an art that can be developed with experience. Avoiding strobe pictures in water where there are suspended particles will save a lot of wasted film. Bright objects reflect light underwater, as will the faceplate of a dive mask. Angling the strobe or camera off to sidelight the subject can prevent reflection and minimize back-scatter (reflection from suspended particles). Objects that appear in the foreground, between the subject and the strobe, may not only be out of focus but may also be "burned out" or overexposed.

Creative use of a handheld strobe will result in pleasing photos. Some photographers use metal arms to extend the strobe's reach, taking care that the strobe does not get into the frame. Flat lighting,

Slave strobes in use

82

where the strobe is fixed in a single plane on the camera bracket, will result in poorly lighted subjects.

Slave strobes are nothing more than light-sensitive electronic eyes that fire the auxiliary strobe when the master is triggered. Some underwater photographers set their cameras up with two strobes on extended arms, one on each side of the bracket or tray upon which the camera is mounted. The second strobe is a slave and goes off when the master is triggered. Two strobes give off more light, which in wide-angle photography will ensure full coverage of the frame. Slave sensors do not work as well where there is a lot of bright ambient light. In most cases, the master must be within about 6 to 8 feet from the sensor for it to fire.

Electronic devices that automate camera and flash equipment are expensive. The newer Nikonos with its speedlight strobe offers automatic features. While automation has gained in popularity, even among professional land photographers, its effectiveness underwater is limited. A reliable electronic strobe which synchronizes at 1/60th of a second, with a wide-beam angle and an acceptable underwater guide number for 64 ASA film, is the basic tool required to take good pictures time after time. This, of course, should be the goal of every photographer. More often than not, automatic features which have a high failure rate in the marine environment complicate rather than simplify picture-taking underwater.

Use of Auxiliary Lighting and Slaves

One of the most dramatic underwater scenes is that of divers, lights in hand, moving over an underwater setting.* The effect is most often captured on film by holding the camera motionless, action moving into the scene. Whether the subject for still photography or film, divers lighting their way or a photographer with camera churning and bright lights illuminating a distant subject provide pleasing effects in the resulting movie or photograph. One such shot, a diver with camera and movie light behind a stand of soft coral, was recently chosen by an editor as the cover photo for my book *Exploring the Sea.*

Normal dive lights do not give off enough illumination to make the picture dramatic. Professional underwater photographs most often equip

*See color section. 83

their models with handheld movie lights. These lights give off a bright penetrating light, dramatically filling the frame. If the camera is close to the subject, care must be taken so the movie lights are not aimed directly at the lens. If this happens, the picture will be burned out, or the lens will be stopped down so far that the surrounding subject matter will not be visible.

Divers in caves or caverns, photographed swimming toward the camera with their lights in hand, yield beautiful results. A photographer with camera inside a shipwreck, jagged hull or superstructure framing divers swimming outside, playing their lights toward the wreckage, will also provide unique effects.

In most cases, where the model with movie light is 10 feet or more from the camera, normal metering will give good exposures. Only slight compensation will be necessary for the bright light. The ambient reading less half a stop is usually sufficient to obtain a proper exposure. Planning coordination with fellow divers before the dive helps the photographer get good set-ups once below.

The larger dive lights often will accommodate a General Electric DWH 100-watt, 6-volt wide-beam cinema light, although the burn time will be greatly decreased. Another method of getting auxiliary lighting in a picture is through the use of a slave strobe. A photoelectric sensor built into the strobe or attached to its connector fires the second strobe automatically when the master strobe is fired.

Where the photoelectric sensor is built into the face of the slave strobe, the strobe must at least partially face the master in order to be fired. A slave adapter manufactured by Oceanic Products can be plugged into the EO connector of any strobe, converting it into a slave unit. This slave adapter is very handy. It enables the photographer to have the underwater model hold the slave strobe in any position, using the strobe's coiled cord to get distance between the slave and master. The slave adapter must point toward the master, but the slave can face any direction.

The main problem to avoid with slave strobe lighting is washout or burnout in the frame. Too much light overexposes the film. Using the slave adapter and angling off the slave strobe not only overcomes this problem but also yields interesting and unusual results. The use of slaves in caves can be particularly effective. Where water clarity is limited, angling off the master so it is used only to trigger the slave and not light the scene helps avoid backscatter that will ruin the picture.

84

Photographers must keep in mind that photoelectric sensors rarely function more than 6 to 8 feet from the master strobe. Where there is a lot of bright ambient light, they may not work at all. Individual experimentation, using light-meter readings and bracketing frames, is necessary to obtain desired effects when using slaves underwater.

In some cases, the use of two or three slave strobes held by different divers has yielded magnificent effects. Colored theatrical gelatins cut to the face of the slave strobe and either taped or held in front of the lens can also add dramatic touches to photography. Reds, oranges or an assortment of colors can be obtained from any theatrical supply house or from the electrician at any playhouse. Almost any colored plastic material will work, including food wrapping paper, although stage lighting gelatins are probably best.

Imaginative use of auxiliary lighting and slave strobes will not only enhance the eye appeal of underwater pictures but will also allow the photographer to work with artificial light where water clarity makes normal strobe use impossible. Slave strobes can create beautiful effects and often prize-winning photographs. Slave photography should be used with restraint in a slide show, however, to optimize the drama the pictures create. Personal experimentation will help develop original techniques and striking pictures.

Filters (Or Better Yet, No Filters)

One theory underlying the use of filters is that red filters will emphasize warmer colors and de-emphasize blues and greens in underwater photography. A filter works by admitting light, in varying degrees, of its own color. Seawater itself acts as a giant filter. Since the tint is cyan or blue, underwater pictures, especially those taken without artificial light, have a blue or blue-green cast. Cyan filters eliminate reds; yellow filters remove or block out blues; and purplish-red or magenta filters block out greens.

Blueness itself can be quite beautiful. A pleasant rendering of blues is one of the reasons Ektachrome film has long been a favorite for underwater use, especially for natural light and distance shots. Early on in an underwater photographer's experimentation, trying out filters is inevitable. And, inevitably, the filter will be abandoned after a few

85

tries, the investment somewhat saved by the continued use of the screw-on filter holder to protect the camera's underwater lens.

Filters cut down available light. Since lighting is critical in underwater photography, the loss of a stop or a stop and a half is not worth the theoretical color enhancement derived from filters.

Some photographers use eccentric colored filters to produce special effects. A well-known underwater photographer confessed that he forgot to take the yellow filter off his camera while on a dive. He finished his roll of film underwater, surfaced and was dismayed to discover that his efforts would probably be a total loss. When the pictures came back, however, a couple of the shots in yellow had nice composition, even though the color was, for all intents and purposes, eccentric. The photographer included one of the yellow slides in a portfolio submitted to a magazine. The yellow-filtered slide was selected by an editor for publication, and the photographer laughed all the way to the bank.

Like colored gelatins, which can be held or taped over a slave to produce varied light effects underwater, a number of filters can be cut out and placed inside the back of the camera lens or even adapted over the outside. The problem with inserting filters inside the back of a Nikonos lens, for example, is that the diver is stuck with that filter throughout the dive.

One filter that is quite handy to have when taking surface shots on water is a polarizing filter. Polarizers cut down the glare off the water and allow the surface shot to show coral and fish under the surface. In the absence of a polarizing filter, I've used my Polaroid sunglasses as a substitute, metering the light first, then holding the glass over my lens. The results are just as effective as with special polarizing filters. In metering when a filter is being used, the photographer must hold the filter in front of the meter to get an accurate reading, then screw it back on the Nikonos lens, making sure no bubbles of air are trapped between the filter and the lens.

There are no mandates or inflexible pieces of advice in underwater photography. Try it. The key is not to invest a great deal of money in underwater filters. They will eventually only lie unused in the camera case.

86

***Warning:** Ni-cad batteries generate hydrogen gas when charging. Always open the unit and charge batteries in a well-ventilated area to avoid the danger of explosion. After a unit is charged, leave it open for several hours to permit dissipation of hydrogen gas. Failure to do this may result in explosion when the unit is fired. Always follow manufacturers' guidelines.

Beware of voltage and current changes when traveling in foreign countries. Plugging equipment into an outlet overseas without a transformer will result in burned out chargers and damaged equipment. If you don't know whether the current and voltage are the same as that specified for your equipment, ask at the local dive shop.

There is always the danger of fire hazard when a charger is plugged in and left unattended. Check the charging equipment frequently. Put a hand on the charger and equipment to be sure it is not dangerously overheating. Keep flammable materials away from equipment being charged.

Chapter Four

Words to the Wise

OH!NOOOOOO! A growl of despair, and then the diver has to laugh. It just ain't funny when expensive photographic equipment is flooded either by accident or through carelessness, but it is bound to happen. Flooded equipment is the avoidable but usually inevitable result of being human. We forget. We jump in without the bottom plug or charging cap in place. We neglect to properly grease and service an "O" ring seal. Anxious to get into the water, we do things in haste, only to grin and bear it later. Here are some common-sense tips that may save expensive equipment or lessen the damage.

Packing and Handling Underwater Photo Equipment

Transporting fragile cameras and lenses requires special care. The large, bulky fiberglass transport cases that must be checked with baggage provide excellent shockproof capability. These cases are expensive, invite theft since everyone knows they contain photographic equipment, count as a piece of luggage where international travel is concerned, and are the subject of close customs scrutiny and

Diver with flooded Nikonos camera in Scapa Flow, north of Scotland. Remedial rinsing and care of flooded equipment is important when diving in such remote areas.

resultant delays at border crossings. Despite the drawbacks, it is probably preferable to protect expensive photo equipment than to worry about possible damage during the trip.

Where possible, the photographer should pack equipment in hand baggage that can be placed under an airline seat. Foam rubber will prevent the cameras from bumping around. On one foreign trip, a customs inspector clumsily unzipped my bag and a lens fell out onto the floor. Luckily, it was in a lens case and no damage occurred. On the same trip, I was flying in a small private plane to a remote island, and the bag containing my cameras was crammed into a tiny luggage space. There were anxious moments wondering whether everything would arrive in good shape.

Fiberglass transport cases may be bulky, but they provide maximum protection for photo equipment.

With these examples cited, it is a matter of personal preference and judgment whether to invest in padded transport cases to pack equipment for travel. Fiberglass cases that will fit under an airline seat are still bulky and will hold only one set of camera gear. The camera cases do have the advantage of being waterproof. They are equipped with an "O" ring seal, and some have pressure relief valves which allow their safe storage in unpressurized baggage compartments.

Storage cases are convenient on shipboard. They will protect fragile gear from bumps and rough handling in stowage. Foam rubber inserts get wet when cameras and strobes are returned to them after a dive. Care must be taken to prevent mildew and fungal build-up in the cases.

On shipboard, a sturdy plastic milk or beverage box may provide a convenient place to stow camera equipment prior to and after use when it is wet. The worst possible thing to do is to put fragile equipment into a bag that gives no indication of its delicate cargo. Weight belts will be thrown on it, and divers looking for a place to sit or lean will crush it. If there is no protected storage area available, it is often better to leave camera equipment in plain view so that everyone will see it.

Very few boat handlers know how to hand a photographer

91

underwater camera gear. Cameras and strobes will be grabbed by their connectors or coiled cords. A few seconds spent explaining to the boat handler how one wants cameras passed will save anxiety once in the water.

A 10- or 12-foot length of line with a clip on the end, secured to the boat and lowered overside with the camera gear attached, is a good way to avoid careless handling. After the dive, when the photographer has removed tank and fins, the cameras can be hoisted aboard. This alleviates the need for boat handlers or other divers to help. The cameras can be stowed away as they are brought on board, and there is less chance that they will be placed in a precarious position. As part of this procedure, a note should be left on the boat's wheel as a reminder to haul in the line before starting the engine. This simple precaution may prevent the loss of expensive camera equipment and prevent the line from fouling the prop.

Many techniques have been advanced for cutting foam padding to the size of camera equipment. Some photographers buy self-stick adhesive shelving that peels back and sticks on top of the foam. A pattern is traced, and the foam and adhesive paper are cut with a sharp knife. Others trace the pattern right on the foam and use an electric

Underwater filmmakers hang their cameras on lines suspended beneath the dive boat for safety.

knife to cut it out. A hot knife works well, but the foam will burn and give off toxic fumes if the knife is too hot. The padding then becomes sticky. Some photographers have had good results when they froze the foam padding before cutting out the pattern. Manufacturers have tried to simplify the task by designing foam with squares that pull out, thus enabling the photographer to pick out the desired design.

Whichever method is used to cut a pattern in the foam for a transfer case, it is an unenviable task. The photographer must also remember to leave ample space between items so they will not hit each other if the case is dropped. In the final analysis, one must weigh the benefits of convenience and hassle-free border crossings against the safety but bulk of the padded case. If one is willing to tolerate the inconvenience, the padded transfer case remains the best way a traveling photographer can protect expensive equipment.

Precautions must be taken when pressure-sealed underwater photographic equipment is transported by air. In unpressurized baggage compartments at 18,000 feet, for example, the pressure is half what it would be on the ground. This creates internal pressure because of the air trapped in the equipment at surface pressure. The pressure can pop "O" rings and damage equipment. Lower pressure inside the passenger compartment of an airplane, even when it is pressurized, may affect photographic equipment that is pressure sealed. The lower pressure in a passenger compartment, however, is not great, and it is doubtful that it will damage equipment. One can actually see the effects of the lower pressure by looking at the Nikonos camera on the plane. Usually the lens will be pushed out, away from the body. In order to protect equipment during air travel, remove "O" ring seals from housings, cameras and meters for unpressurized air transport or take less risk and carry them on board.

First Aid and Field Repairs
For Underwater Photo Equipment

To avoid flooding of underwater equipment, one simple piece of advice will go far—do everything right away. Complete each step until the equipment is watertight before putting it down. This applies to strobes as well as cameras. One of the most frequent causes of

93

flooding of underwater equipment is the failure to replace a strobe recharging cap, the synch plug in the bottom of a Nikonos camera, or some fitting. Such things are easy to forget while on a dive trip or aboard a boat and changing film. A diver sometimes removes the adapter cord from a camera, services the strobe, and then comes back and washes the camera in fresh water, forgetting to put the synch plug in the camera. In the older Nikonos cameras this would result in a flooded camera.

The human mind forgets and is easily distracted. The one discipline to prevent accidental flooding is to fully service a piece of equipment before leaving it. If servicing can't be completed, a large piece of note paper taped on the equipment will serve as a reminder. One quick example will graphically illustrate the importance of this advice. A diver charged his strobe and left it in the hotel room without replacing

the recharging cap. At dinner the diver was invited on a night dive. He hurried back to his room, grabbed camera, strobe and dive gear and headed for the boat. The diver jumped into the water without replacing the cap and flooded the strobe. His picture-taking on that particular tropical holiday was over.

No matter how careful a photographer tries to be, flooded equipment is bound to present a problem at one time or another. In most cases a flooded camera or strobe cannot be repaired in the field to get it back into service. If the purpose of an expensive diving vacation is to obtain underwater pic-

Look before you leap! Flooded equipment can mean expensive repairs, as well as an end to your picture-taking holiday.

tures, a second set of backup equipment should be available for emergency use.

Handling flooded equipment promptly and in the proper manner will minimize the damage from corrosive salt water. Even worse damage can result from ill-advised handling of flooded equipment. Robin Smith, one of Australia's most famous nature and landscape photographers, was on assignment in Tahiti and was using his favorite Rollei body, worth about $5,000, and equipped with a telephoto lens that cost $3,500. His Luna Pro meter was hung around his neck. Standing to photograph a water skier behind a speeding boat, Robin was thrown off balance when the boat veered and he tumbled into the lagoon. After his camera equipment was recovered, one genial fellow suggested soaking it in gasoline to counteract the salt water. The gasoline melted the plastic meter parts and camera box facing material, which attacked the lenses and made an almost unsalvageable mess out of the equipment.

If only a few drops of salt water get into the camera equipment, it can be dissolved and removed with ethyl alcohol. After being wiped on, the alcohol will evaporate. Alcohol should not be placed on lenses, since it will remove their coating. Lens cleaner should be used. Where saltwater flooding is extensive, the salt water should be drained and the camera soaked in fresh water. Working parts should be moved to ensure that the fresh water gets to them. After removing the camera from the fresh water and draining off the excess, pack it in a plastic bag and transport it to a repair station as quickly as possible.

If one is diving in a remote area and it will be more than a few hours before the camera can be professionally serviced, the camera, after a thorough washing in fresh water, can be soaked in alcohol, field stripped and dried with a gentle air stream from a dive tank. If the Nikonos camera has to be field stripped, the only parts that should be removed for washing are the two screws that attach the protective plate at the base of the camera beneath the take-up spool. This will expose the working parts. Going any further requires sophisticated knowledge about camera repair and should not be attempted by an amateur. After washing, rinsing with alcohol and drying, a silicone spray on the working parts will keep them corrosion free. Do not spray grease or oil into the camera. Keep all sprays, even silicone, off the

shutter curtains.

If a strobe is flooded, most manufacturers recommend that it be opened and, if powered by disposable batteries, that they be removed and discarded. High-voltage batteries in a flooded strobe must be handled with extreme care to avoid electrical shock. Remember that a strobe's capacitor stores a deadly charge, even when the strobe is "discharged," so be very careful.

If the strobe is sealed by the manufacturer, such as the Oceanic ni-cad equipped strobes, do not break the seal. With Oceanic strobes, grasp the plastic ready light cover with a pair of pliers and screw it off. Dump out the seawater, shaking the strobe vigorously, and then flush it with fresh water. When the strobe is flushed and emptied, pour alcohol into it and reseal the ready light port. Send it back to the factory. Strobes that come apart for battery insertion should be flushed with fresh water after the batteries are discarded and returned

Flooded strobe being given first aid on shipboard

96

to the manufacturer. Alcohol can be used to evaporate the fresh water. An inexpensive ohmmeter can prove invaluable in testing and troubleshooting connectors and contacts. An ohmmeter measures electrical current. If there is a short in the wiring or circuit, it can be detected with the meter.

Isolating the problem is the first step in troubleshooting. This can be done with or without an ohmmeter. A strobe that failed to fire may be the result of a faulty contact inside the camera, in the synchronization socket, in the connector and cord or in the strobe itself. The quickest way to troubleshoot the strobe is to turn it on and make contact with the connector or EO contacts using an insulated pair of pliers or a bent piece of insulated electrical wire, bare at both ends. If the strobe fires, it is not the source of the problem.

The next step is to attach the connector, if it is an EO, and touch the contacts. If the strobe fires after doing this several times, each time bending the connector wire at its base to test if the wires are loose or broken inside, one can determine whether the problem stems from the connector. If the problem is still not isolated, remove the camera body, if a Nikonos, or open the housing. With the strobe and connector attached, make contact inside the camera or housing. If the camera is an older Nikonos, make contact with the two outside metal feet. Once the problem is isolated, the defective piece of equipment can be replaced.

A small plastic refrigerator storage box or other suitable container will make an ideal tool kit to take on a dive trip. A set of jeweler's screwdrivers, extra "O" rings, a plastic bottle of alcohol, a can of silicone spray, cotton swabs, lens cleaner, a small pair of Vise-Grip pliers and an inexpensive ohmmeter are very handy to have along.

After being used, cameras, strobes and other equipment should be soaked in a large pail or sink containing fresh water. After soaking, the equipment should be rinsed gently with fresh water from a hose and dried. Water droplets remaining on a lens will leave stains. If it is necessary to open a camera, strobe or housing on a boat or beach, use care to do it in the shelter of a cabin away from sun and spray. Open the equipment so water droplets from wetsuits, face, hair, or equipment will not fall inside.

A final word concerning older model Nikonos I and II cameras. If

the tension on the trigger of these cameras is off, the arming mechanism can slip. The tension can be adjusted with a jeweler's screwdriver by slightly turning the set screw on the camera body just in back of the shutter release arm until the situation is corrected. Avoid trigger thumb releases on earlier Nikonos cameras.

With all cameras, regardless of model, use care when inserting connectors in the synch plug so as not to twist the internal camera parts. Never force anything that doesn't seem to be working right. Repairs to photographic equipment are very expensive, and using care when loading and putting camera equipment together will go a long way toward preventing accidents with costly consequences.

Part Two

Technique

It is an easy enough matter to drill on how to use a piece of equipment—how to load a camera, how to hold it, how to care for it and repair it. Taking underwater pictures is easy. Taking *good* underwater pictures, however, involves much more than the obvious mechanical skills.

Good underwater photography reflects a mastery of the mechanics and an artistic sense of balance and composition. A little luck also helps. Being at the right place at the right time and being ready to capture a rare moment on film is a matter of chance. Nature may choose not to cooperate with the diver setting off on a great expedition to capture a specific large or dangerous species on film, while the occasional diver may unexpectedly witness some amazing underwater event.

Good technique comes with experience and depends in part on what can only be described as a certain pzazzz—that indefinable quality of flamboyance, originality, uniqueness or other more subtle touch that unmistakably distinguishes the good photographs from the commonplace. Personal taste is obviously a component of some

99

aspects of technique. Parts of this section must therefore be regarded as opinion rather than hard fact. Nonetheless, the suggestions provided, based on feedback from years of experience in publication and public showing of photographs, will increase your chances of getting professional results.

Chapter Five

Taking Good Pictures

Doing something by hand leaves one with a wonderful sense of satisfaction and accomplishment. This sense of creativity is prevalent in all the arts, and photography is no different. There is always an air of excitement when the pictures come back from the lab or when the instant Polaroid slide film is wound back into its roll and the film examined for the first time. How did they come out? Did the close-up shot work? *That* one belongs on a magazine cover!

The Picture is the Payoff

Not every underwater photographer is going to enjoy lugging camera equipment around, handling it on the boat, sometimes struggling with it underwater. But when those pictures come back and some have turned out well, the excitement and fun that can be shared with others capture center stage. An audience quickly gathers around

101

Obtaining a good vantage point aids in getting exciting photos. Here
Calypso's helicopter hovers while the camera operator films, aided by a
special camera mount.

a diver with photographs showing the activities of a club dive. I've had
divers come to the developing lab and offer to buy copies of slides
taken that same morning. On one occasion I took a picture topside of a
dive party with an underwater wide-angle lens to have an instructional
photo demonstrating why this doesn't work. Two people in the picture
wanted a copy of the photo, regardless of its quality, as a souvenir of
their trip and as a remembrance of friends they had made.

That's part of the payoff. Photos help to make and maintain
friendships. On a more individual basis, underwater photography
offers the satisfaction of meeting a challenge, developing discipline in
an alien environment and surmounting mechanical and physical
obstacles. It is doubly satisfying to accomplish a task that involves
both intellectual ability and manual skills.

The realm of underwater photography also provides the oppor-
tunity to study creatures in the sea and to share that knowledge with
others. It is only relatively recently that ocean scientists have begun to
dive and even today there are few diving scientists. Many scientists
rely on material dredged up from the ocean bottom in trawls. They
base their research on static, mostly dead, specimens without ever
seeing the organism alive in its environment. Divers can often
complement the work of non-diving scientists by offering their
observations and pictorial documentation.

102

A case in point involves Florida diver Norine Rouse. Norine dives every day of the year in the waters off Florida's east coast. She plumbs the Gulf Stream, making observations, taking pictures, and accumulating pictures of marine life taken by divers who sometimes accompany her on dives. Norine's great interest in sea turtles became the focus of scientific work on these endangered species. Pictures displayed by Norine at meetings of scientists at the International Turtle Conference, as well as her firsthand observations, have added immeasurably to the scientific understanding of these magnificent sea creatures.

Underwater photography is sharing an experience with friends, a means of documentation for intellectual study, a way of learning and recording that knowledge, and a mechanical means of completing a challenging task for the diver who wants to do more than hammer at things with a chisel, shoot fish, or just look and observe. Perhaps only one or two slides out of an entire roll may prove to be special pictures, but they are the payoff. As with many recreational or professional pursuits, the most important thrill of underwater photography is self-satisfaction. Whether a photographer has the special picture published in a magazine or puts it in his personal album, the ultimate goal should be to do something that stimulates and challenges one's own intellect and imagination. As an extension of the purpose of diving and the result of this goal, the picture is the payoff.

Shooting Themes and Composition

Composition is nothing more than setting up a picture so it looks good. Shooting themes is when a photographer puts several well-composed pictures into an interesting series.*

Volumes have been written about composition. Land photographers often spend a great deal of time trying to "learn" composition. In underwater nature photography, with the exception of posed pictures using models or aquarium-saved specimens taken out for a walk, you take what you get. The second shot is usually the tail of a fish swimming away. Having a good eye and an ability to make a quick evaluation of how a subject can be framed in a rectangle helps immeasurably.*

* See color section. **103**

Waiting until a fish turns three-quarters before snapping the picture or using lighting creatively can make an ordinary subject quite pleasing. Depth of field used creatively can also yield interesting results. Having the field in back or in front of the subject in or out of focus adds or takes away emphasis.*

Composition emphasizes certain aspects of the picture. Perfectly centered frames are usually the goal of a beginning photographer. The eye, however, does not always judge aesthetics symmetrically. A fish somewhat off-center in the frame may be more appealing; it may yield better composition.

A photographer with a constant eye out for animals that exhibit adaptive behavior can put together an interesting series. After the initial picture-taking of general subjects is done, a photographer can lend a more fine-tuned purpose to a photo dive or series of dives by taking pictures of animals which change color, exhibit mimicry,* are engaged in hunting or seizing prey, or have venomous defense mechanisms. Much can be learned about animal behavior by looking closely and concentrating on finding and photographing themes. Shells, algae, nudibranchs, sponges and camouflaged animals all lend

An off-center subject may result in better composition.

104

themselves to a series of pictures. Color changes in the same animal, for example, are fascinating to watch and photograph, and they dramatically illustrate an aspect of animal behavior when projected.

John Stoneman, president of Canada's Mako Films and one of the world's leading underwater filmmakers, has capitalized on his understanding of an animal's flight range. Through years of experience, Stoneman has learned not only how to approach animals underwater so they won't be spooked but also just how close he can get before the animal swims away. Using an Arriflex 16-mm movie camera with a special zoom lens, Stoneman has found that he can remain just out of most animals' fear and flight range and still get the dramatic close-up pictures he needs for world television. Stoneman's rare and exceptional footage has enabled scientists to gain new insight into shark behavior and their attack-syndrome body language.

Knowing how animals behave underwater comes with experience. "Over years of diving," says Stoneman, "we have developed a lot of experience diving with sharks. Instinctively we can predict how these large animals will behave under certain circumstances. When they are exhibiting aggressive behavior, we had better leave the water!" While animal behavior in the wild is said to be unpredictable, the diver who gains experience at working with marine creatures will find it easier to predict what animals will do and to compose pictures and develop themes around these predicted behaviors.

A beginning photographer would do well to critically examine the published work of other photographers, land as well as underwater. Try to analyze why certain pictures appeal to the eye. What qualities in any given picture make it pleasing to look at? How have the pictures in a book or magazine been grouped to present a logical flow, develop a theme, or explain something. The eye and creative nature of a photographer's mind will coordinate in the underwater setting if certain details as to what makes pictures pleasing have been learned beforehand.

In the end, a photographer must please him or herself first. If care and creativity go into the picture-taking process, then just as you are attracted to the work of certain photographers for reasons of your own, so will your photographs attract an audience. Composition, after all, is structure, and a picture is "built" by eye in the same way an

artist conceives a painting. Putting things where they are in a picture is a matter of taste and preference and judgment. If an underwater photographer's pictures are to be judged by others rather than taken for personal enjoyment, then a few hours devoted to studying the "style" of published pictures will help develop standards. In no way should this study of the successful work of other photographers stifle individual creativity. Composition, if it is to be meaningful at all, should be part of a photographer's personal style.

People in Pictures

I signaled for the diver to move closer to the soft coral. It was a beautiful cluster, hanging off a wall. Dropping a few feet below the diver, I wanted the coral lighted with the strobe and a contre-jour shot of the diver against the wall. The diver apparently misunderstood, for in the next instant she picked up the soft coral and lapped it over itself on the ledge. I was too busy laughing to wonder why my signal was interpreted to mean tidy up the coral. As this story clearly illustrates, underwater modeling is an art that requires not only some advance preparation, but also an understanding by both photographer and model of the objectives of the dive.

Some dive gear worn by models is not suited for underwater photography. Certain masks make people look like frogs; others conceal the eyes and facial expressions. Divers with plain round masks that show off most of the face look best on film. Some professional photographers obtain promotional equipment for use in their films or pictures. These pros are obligated to suit up their models in particular wet suits, tanks and vests. The average underwater photographer, however, pays little heed to what the diver is wearing. One picture taken of me holding a puffer fish zoomed in on my old torn neoprene gloves. The picture looked terrible—an underwater hobo, bare fingers protruding and torn gloves flapping. A moment's attention to remedy obvious eyesores can make for better pictures.

Betsy and Allan Edmund, owners of Henderson Aquatics in New Jersey, have developed wet and dry suits that complement photographs and yet retain their functional properties. Before going on a recent assignment to the cold north of Scotland to explore the scuttled

German shipwrecks in Scapa Flow, I consulted the Edmunds as to what material and color scheme would best suit the conditions. Allan recommended one of the new Henderson dry suits, and Betsy chose a silver color to stand out in the subdued light in the Flow. Color and underwater dress is a matter of preference, but if one is going on a long trip specifically to take pictures, thought should be given to the model's appearance.

Patti and Tom Mount have also helped to make underwater fashion fashionable. Tom is one of the world's best still photographers and often hires out when Hollywood needs a top dive instructor or cameraman. Tom and Patti have pioneered and refined underwater modeling techniques. The new and exciting splash of bright and attractive wet suit colors and styles on the market today can well be attributed to their fashion-conscious photography. Drab is dull, and although we like to tease "Peppermint Patti" about her wardrobe of wetsuits and color-coordinated masks, she and Tom have indeed put color back into color marine photography.*

A diver posing for pictures should move with grace underwater. A bicycle kick or the use of hands to swim underwater usually yields inelegant pictures. Since few instructors really stress basic snorkeling skills, it may be necessary for a photographer to retrain a model to swim underwater with style.

A certain amount of understanding of photographic technique is also imperative if a model is to work well with an underwater photographer. Working close to marine life so that both the model and the specimen fit well in the frame's composition is as important as the model not spoiling the picture by kicking up dirt and silt with fins.

Diving with groups often makes picture-taking impossible. Flying fins, as well as debris descending from the walls, and drop-offs as divers above kick the coral with their fins, create frustrating problems for an underwater photographer. By the time the last of the group crashes off the boat and into the water, the larger marine life has usually taken off for parts unknown. Diving with one buddy, both slipping quietly into the water, is the best of circumstances for an underwater photographer. Trips to dive resorts, if they are for the express purpose of taking pictures, should be carefully planned. It is best to avoid being crowded aboard a dive boat with novices who step

* See color section.

on fragile camera equipment and who can frustrate your photography efforts underwater.

There is a strong temptation for divers, especially instructors and guides, to grab marine life and try to hold it up for the photographer. If obtaining natural shots is one's goal, this should be made clear before going into the water. It is also wise to have an understanding with divers in a group not to move abruptly toward marine life. The mad rush often scares fish away, making it impossible for a photographer to set up a good picture. Patience always pays off in underwater photography. The inherent curiosity of marine animals will attract them to divers who do not exhibit aggressive moves underwater.

Getting to know the habits and preferences of marine creatures will pay dividends in obtaining good pictures. As mentioned, Norine Rouse has been diving in the Gulf Stream off South Florida's coast for many years. Over that period of time, Norine has developed a special relationship with marine turtles, which she found return to the same place year after year. Divers have often attempted to ride the turtles or hold them by grasping their shells from the top. Norine found that the turtles disliked being handled in this fashion. The turtles would permit her to hold a flipper and swim beside them. The turtles would more than willingly pose for photos with divers and not swim off in fear, but only after divers learned something of their preferences and responded accordingly. This notion must be communicated to underwater models.

People appearing in pictures with marine animals can add drama to underwater photos. Their reactions may even add a sense of danger or adventure to the scene. The illusion of danger, created artificially, is one thing. Exposing underwater models to actual danger is another.

Many filmmakers and photographers have been sought out to obtain dramatic shark pictures. This is accomplished by spearing fish or spilling chum in the water. The results are dramatic, but they also alter the animals' behavior patterns and make it impossible to predict their reactions. Underwater models working in these conditions must be alert to the danger, and adequate safety precautions with back-up divers should be incorporated in contingency plans to deal with the unexpected.

People pay to see danger. There is a blood lust factor that sells

108

Danger, real or apparent, adds appeal to a photograph. Large and dangerous species, however, should be left to the specialists.

action pictures where risk is involved. Underwater photographers and models who work with large and potentially dangerous species are specialists. Their techniques are not for the amateur. Respect for a model's safety and comfort, including such precautions as protective gloves and clothing in areas of fire coral and sharp-edged shipwrecks, should be paramount in any photographic project.

Chapter Six

Capturing

Nature On Film

To film the living reef and show nature's harmony without disrupting it poses a greater challenge and requires more skill and patience than merely taking aim and squeezing the trigger of a gun. If there is any truth to the idea of modern man having the hunter-stalker instinct, then the craving can be satisfied just as easily with a camera as with a gun or spear.

Collecting on Film

Humans are collectors. In one of its most aggressive forms, the human fascination with collecting is conspicuous in the trophy hunter. Once proud and wild animals lie stuffed and dust covered, their horns and pelts used as ornaments, coat racks or carpets. The urge to dominate, even through killing and destruction, has tracked mankind's progress over the face of the globe. Attempts to justify the senseless slaughter of wildlife are impossible. We can only wonder why trainloads of ordinary people crossing the Great Plains would fire at herds of bison merely for the fun of killing them. Even today we

must wonder why greed and other base motives in the harvesting of whales and other wildlife species have pushed many of the most magnificent and intelligent creatures on Earth to the verge of extinction.

What we don't kill, we cage. The same destructive impulses that drive the graffiti artist to initial the walls of Central Park often inspire onlookers to throw trash into the sea lion pen or taunt the great apes and regal tigers with jeers and morsels of junk food thrown at them through the bars. Caged or uncaged, animals are losing their status as an integral part of the scheme of life on Earth. More and more often they are simply ignored as inconsequential in the face of commercial interests that make fortunes out of forests, pollute oceans and push animals aside to support an overpopulated world.

Underwater photography offers the person with the collector's instinct a creative way to conserve nature. The photographer can intrude on the undersea setting with dignity, taking away images and leaving the beautiful creatures of the deep sea to survive. The stalker with the camera must be more clever than the safari hunter, for the key is to capture life in the beauty of its natural state without damaging it.

Simply swapping a chisel and spear for a camera, however, is only a physical step. Protecting and conserving the beauty of life in the oceans demands an intellectual commitment. Capturing nature on film and sharing it with others requires that life in the oceans not be destroyed or disrupted for the sake of art. A rock or piece of wreckage that is turned over during exploration should be gently replaced in its original position to preserve the organisms living on and under it.

In places like the island of Bonaire in the Caribbean, where hundreds of visitors dive over the same reefs each year, physical destruction by diving photographers has already begun to take a toll. Divers break off pieces of coral and smash delicate formations with their fins and the bulky body gear worn to prevent stings and cuts. Captain Don Stewart, owner of Captain Don's Habitat on the island, tries to prevent damage by warning photographers of the delicate nature of the reefs. "But still," he says, "photographers go down with knee pads, elbow pads, gloves, wet suits and boots. They smash the reef to bits, lying on coral and kicking it with their fins. They are only interested in their picture, and some of them will destroy the reef to

112

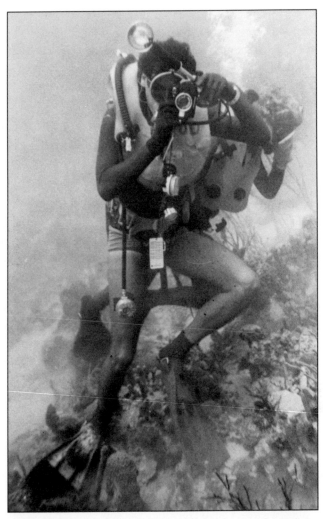
Deep in concentration, an underwater photographer may forget that his dancing feet are damaging coral.

get it."

He's right. Photographers, often lost in deep concentration and vying to get that special picture, sometimes forget the important principles of diving safety and conservation. The cumulative effect of hundreds of divers can have disastrous results. Captain Don urges

that certain reefs be closed off from time to time to let them recover. He also insists on permanent moorings to keep anchors from breaking the coral. Such common sense conservation means survival to Don Stewart and his island of Bonaire, which derives income and sustenance from the divers who visit the undersea reefs. Photographers who heed his advice will always be welcome on fragile coral reefs and will help ocean communities survive in their natural state.

Macro Close-Up Photography

Fine latticework fingerlets, their delicate filaments white against brilliant red coral. Pulsing, the polyps draw minute plankton toward their oral cavity. Captured on film, the delicate majesty of this small colonial animal fills the projection screen with beauty.

While underwater photographers may spend thousands of dollars equipping their cameras with wide-angle lenses, more often than not the most stunning and appealing pictures are close-ups. Close-up pictures underwater can be taken with simple and inexpensive extension tubes or clip-on and screw-on lenses added to the camera's own lens.

Powers of observation will develop after a diver gains experience. No one put it more poignantly than Norine Rouse when she said, "It disappoints me when people come up after a dive and say they didn't see anything. They didn't look closely. There was life all around them." Saying nothing was there means that divers have looked but have not seen. The eye for detail, the extra minute it takes to look closely, is often rewarded by the discovery of a micro world that holds insight into fascinating bits of natural history and animal behavior. Occasionally the close-up lens captures more than was originally seen by the naked eye. The underwater photographer has often been surprised to find minute shrimp hidden on a basket sponge or tiny crabs perfectly camouflaged amidst the encrusted life on a pier piling.

Using strobe lights to bring out the color and stopping down the lens to take advantage of maximum depth of field, a photographer can spend many hours in shallow water discovering the beauty of minute species which inhabit the marine environment. Divers in colder waters, where water clarity may be diminished, can concentrate on

114

close-ups to obtain stunning pictures of marine life.

Depth of field is critical in macro photography. The area in focus in front of and behind the subject can be increased slightly by stopping the lens down as much as possible. The smaller the lens opening, the greater the depth of field. In most cases, however, the area in focus is not much greater than two or three millimeters. It is important to carefully frame the subject at the proper distance to be sure it will be in focus in the picture.

Underwater photographers use many techniques to capture appealing close-ups underwater. One of the simplest techniques involves an accessory lens that is screwed in or clipped over the standard lens. Using care to be sure no air bubbles are trapped between the clip-on lens and the camera lens, a photographer can dive with one camera and switch back and forth to macro. Some of the clip-on lenses manufactured for use with the Nikonos underwater camera come with framers attached. Several of the macro clip-ons use a variety of sticks to indicate distance.

While clip-on lenses are convenient for the diver with one camera, who may not want to dedicate the dive solely to close-up work, clip-ons have some drawbacks. One practical problem is the difficulty in securing the lens and framer safely when not in use. Many have been lost by divers attempting to secure them to weight belts or dive gear. In addition, clip-on lenses made of either plastic or ground glass do not have the same optical quality as original camera lenses. The resolution or sharpness of an underwater picture taken with a clip-on lens is rarely as good as those taken through the camera's original lens using an extension tube.

Macro photos can be taken with a variety of extension tubes which are simply inserted between the camera and the lens. Extension tubes come with wire tines called framers. The subject is in focus if it is kept well centered in the framers. Anything in front or behind an area of about the width of the wire framer tines will be out of focus.

When clip-ons or extension tubes are being used, experienced underwater photographers debate whether the camera lens should be set at infinity or the closest distance, which for the Nikonos 35 mm lens is 2.75 feet (0.8 meters). Since depth of field is not greatly increased beyond the few millimeters in front of and behind the

115

Wire tines called framers can help keep the subject in focus.

subject, the debate is by and large academic. Most pictures will be in focus if the camera lens is set at the closest distance.

In theory, if one wanted the area beyond the subject to be in focus, then the lens should be set at infinity. If the photographer prefers a small area in the foreground, between the lens and the subject, to be in focus, then the camera lens should be set at the closest distance. In either event, the depth of field in macro photography will not be greatly enhanced, even at a setting of f/22. A few personal experiments under actual field conditions will bear this out.

A variety of add-on or screw-in lenses are available for Nikonos amphibious cameras and other models. Some underwater photographers call these "Eighteen-inchers," and often adapt land lenses

for underwater use. A number of companies make screw-on lenses expressly for underwater photography. Hydro Photo markets a series of lenses that screw into the threads of the Nikonos 35 mm and 28 mm lens. These lenses yield about the same or slightly better fidelity as the clip-ons. They can be bought with adjustable wands which help guide the photographer in judging the proper distance.

The screw-on lenses are convenient for the photographer with only one camera who does not want to be irretrievably dedicated to shooting only close-ups and miss a once-in-a-lifetime shot of a whale swimming by. It is a trade-off—practical use and convenience for quality and resolution. The ideal solution for the Nikonos diver is to take two cameras below, one for normal or wide-angle shooting and the other equipped for macro work.

Housed cameras with through-the-lens focusing offer the best of both worlds. Using a large sport finder, the Nikon or Canon SLR camera equipped with a 55 mm Micro Nikkor or similar lens can shoot anything from 9 inches to infinity. Through-the-lens focusing allows the photographer to see what the picture is going to look like. Using a housed camera underwater takes some getting used to, however, and the diver may find that it is not always easy to focus in subdued light, even when using a camera equipped with a sport finder.

Cinematographers using close-up equipment and through-the-lens housed cameras have very effectively captured the movement and behavior of minute marine life on film. The filming equipment must be held perfectly still so as not to disturb the reef life being filmed and cause unwanted movement. Small, lead-weighted tripods set up near the subject with remote shutter releases aid in filming plume worms, small blennies, jaw fish and other reef life. Lighting is critical. Movie lights can be handheld or mounted on the camera to obtain the desired lighting angle.

One technique that provides dramatic close-up pictures is to gently lift the animal off the bottom and photograph it in mid-water. With a camera stopped down to f/22, the subject usually stands out in a dark field. Remember to treat the small creature gently and to return it to its original niche after taking the picture. The use of such close-ups adds a colorful and appealing dimension to underwater films and should be directed into any story line.

117

Anything that sticks out in front of the camera tends to scare away the subject. Fish, eels, even sessile tube worms retreat just as the photographer moves the macro framer toward them. One way around this is to take a hacksaw and cut off the vertical tines of the framer. Use of just the bottom bar will allow a fairly good estimate of the framing, and the absence of the tines will help get the camera into position.

An extension tube and framer made in Japan and marketed by Dacor in the U.S. have spring-like vertical tines. The springs can be unscrewed from the framer. The best procedure is to unscrew these tines and leave them off. The springs often bend inward and intrude on the photograph. The R3 Dacor tube, like the Gates Underwater Products 3-to-1 extension tube, yield quite good results. Their large field makes them useful in macro photography.

Extension tubes marketed by Oceanic Products come in a set which includes two tubes and three framers. The extension tubes in the Oceanic series permit close-up photography in 1 to 1, 2 to 1, and 3 to 1 ratios. The tubes are color coded to the framers to make their assembly easy. When two oceanic extension tubes are used together, a 1 to 1 ratio is obtained and the framer is the same size as a 35-mm film frame.

Nikon sells a close-up set for its Nikonos lenses. The Nikon set consists of a clip-on lens which is fixed over the camera lens. Wire framers encircle the entire subject underwater and aid in framing it. The Nikon set is fairly expensive and somewhat unwieldy in the water with the large metal framer. The optical quality of the lens yields excellent results.

Lighting is important in macro photography. In most cases the strobe to subject distance is about 9 to 12 inches. Care must be used not to burn out the subject with too much light. The strobe should be held in a position so the subject will be fully lighted. Side lighting can be effective, but good results are obtained by hand holding the strobe over the center of the subject from the top. Back lighting is a technique used with transparent subjects—the lens on one side of the vase sponge, for example, and the strobe on the other.

Brackets and arms often get in the way during close-up photography. A detached strobe with the dynamic maneuverability of the human hand is the best way to obtain satisfactory results. Care must

118

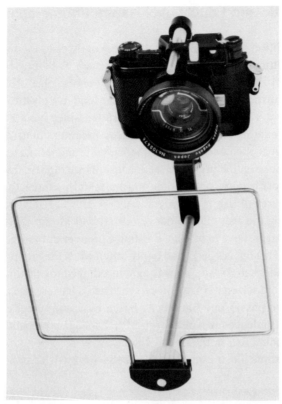

Wire framers included in the Nikon set literally frame the entire subject.

be taken, especially with the R3, 3-to-1 or larger format close-up sets, to avoid getting the strobe into the picture. It must be held up and out of the way. Experimentation with both the angle of the light and camera will suggest effective ways to capture small reef life on film.

With the Oceanic 2001, Subsea 150 or comparable electronic underwater strobes, at 1/60th of second and using 64 ASA film, settings of f/22 or f/16 work best with the flash 9 to 12 inches away. Guidelines published with strobe or macro sets give a starting point for proper camera settings. Bracketing and experimentation are the best insurance for good macro photography.

119

Dramatic and Educational Nature Photographs

In addition to changing the scheduling of dives to include evening and nighttime hours, simple techniques such as baiting fish can be employed by divers to obtain interesting shots. One of the easiest ways to attract fish is to bring down some food in a plastic bag. Some divers prefer to use bread for this purpose, since meat attracts the larger predatory fish, like grouper, that preempt colorful reef fish. Some divers open a sea urchin with their knife and retreat to watch the fish advance on the urchin to feed. Most photographers find that it is best to work in pairs, one feeding and one taking pictures, to obtain the best pictures of fish.

Feeding the fish can be dangerous. It will attract predators and provoke aggressive behavior. Feeding a grouper in the Red Sea, one diver had his fingers and hand badly bitten when the grouper, seeking more food when the supply was exhausted, mistook the diver's hand for food and seized it. In my own experience, I have seen sharks make aggressive passes and have been bitten by a moray eel during fish feeding. Prudence must be exercised and adequate precautions taken when feeding fish in the open ocean.

Trick shots illustrating territorial behavior by fish can be obtained

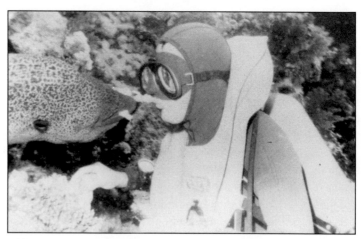

Although this cooperative moray is taking food out of a diver's mouth, such stunts are best left to experts.

by using mirrors underwater. Confronted with a mirror in its territory, a fish will make passes at the "intruder," often opening its mouth and gills in menacing gestures to scare off the imaginary invader.

If a diver is prepared to be patient, many interesting photographs can be taken illustrating commensal behavior. Some of the most stunning photographic examples of this kind of behavior are those taken of clown fish in a sea anemone.* Close-ups of the clown fish swimming in and out of the stinging tentacles will reward a patient photographer. The orange and white stripes of the clown fish among the purple-tipped anemone tentacles are striking on film. Shrimp can also be photographed among anemone tentacles. In both cases, the pictures describe the phenomena of creatures living together for mutual benefit.

Taking time to research behavioral characteristics, including aspects of adaptive behavior and coloration, will enable the photographer to specialize and concentrate on obtaining a series of pictures that describe certain aspects of animal behavior. A series of pictures of a peacock flounder as it moves over differently colored substrate on a reef will add a fascinating dimension to an underwater slide show.

Sedentary animals that exist in a variety of camouflage forms also add interesting highlights to a slide show. "Find the fish" in two or three frames is one way for a photographer to involve an audience in the slide show or to educate fellow divers to adaptive behavior. A series of slides for this purpose can include a flounder concealed in the sand, a stone fish camouflaged on the bottom, a file fish changing color to resemble a piece of soft coral, or a trumpet fish vertical to a branch of coral. Imaginative combinations add to the photographer's enduring appeal as a presenter. Learning about the creatures being photographed, seeking out the subjects underwater, and presenting the resultant pictures in a series that educates the viewing audience adds a special dimension to the craft of underwater photography.

Picking a theme and setting about collecting a series of pictures for illustration is another means of extending the scope of one's photographic interest. A theme based on biters and stingers on the sea floor, for example, provides animation and excitement, as well as a captivating educational experience. While few photographers go below to photograph just one sort of fish or marine organism, keeping

* See color section.

a theme in mind and seeking out examples will broaden interest and give a photographic hobby longevity and purpose.

Key elements in the work of successful nature photographers, especially those who specialize in underwater work, can be boiled down to a few short, surefire ingredients: 1) an element of danger—apparent or anticipated danger where the diver-photographer runs a risk because of the nature of the subject matter; 2) natural behavior that describes an interesting or educational phenomenon; 3) human interest and adventure. People like to see people and know a little about what the subject is doing and experiencing. Facial expressions are important visual indications in communicating emotions of subjects in the pictures.

Chapter Seven

Special Photo Opportunities

Sometimes an unusually beautiful or dramatic underwater event takes place and the photographer is on hand to record it on film. More often than not, observation and creativity are required to take advantage of special photo opportunities available during every dive. The following techniques and suggestions will help make any dive a special opportunity for good pictures.

Night Diving for Pictures

After a night dive, especially in the tropics, divers often ask in wonderment why they even bother to dive during daylight hours. The underwater photographer is particularly impressed with the new opportunities presented by night diving. The life of a reef takes on a noticeable change toward evening. The sun is at a different angle and the colors and hues of the reef appear subdued. An atmosphere of easy relaxation drifts over the reef as the fish begin to quell their daytime activities and marine life slowly seeks the niches they will occupy for the night.*

* See color section. 123

Night diving is easiest when a diver is familiar with the reef. Landmarks underwater reassure the photographer and make it easier to find subjects. The reef life itself remains fairly stable unless disturbed. Often the fish, shrimp, lobster, crabs or eels which were impossible to photograph during the day come out at night to feed and become ready subjects for the night hunter with a camera.

Artificial light is necessary, both to light the way for the diver and to aim the camera and strobe. Strong lights, while convenient, often scare marine life with their intensity, consequently destroying any chance of capturing the subject on film. Smaller, less intrusive dive lights that serve both as a pilot light to guide the strobe and as a dive light are preferable. The small and popular Q and QXL dive lights manufactured in California by Underwater Kinetics are excellent for this purpose. With rechargeable batteries that provide long burn time and a bright but narrow beam of light, they are adequate and dependable. Since the beam is narrow, the lights expose only a small portion of the reef at a time. This gives the diver a chance to study the area and compose a picture before moving on. Wide beams tend to disturb a larger area than the photographer has time to consider and photograph. Thus, when the diver finally focuses attention on the edges of the beam of light, the fish, octopus and other motile life forms have moved off. In the case of sessile marine life, such as anemone or corals, they will already have retracted their tentacles and retrenched to avoid light.

The less intrusion the better. While divers have resorted to taping dive lights to the top or side of their electronic flash to serve as a pilot light, inexpensive holders are available from Underwater Kinetics that mount the light next to the strobe. Some underwater strobes, including those manufactured by Subatec in Switzerland, have built-in pilot lamps that help aim the strobe being fired and act as a dive light as well.

Although the beam from the dive light, unless extremely brilliant, will not generally affect the guide number setting, the effect of light on reef life is the same as when a light is shined in the eyes of a person sleeping. Fish and marine life become startled and disoriented. Unable to see and swimming into rocks or coral, they may harm themselves while trying to flee. The intrusion prior to the flash going

off should be as gentle as possible to capture the natural setting.

Close-ups of coral polyps extended for feeding at night make magnificent subjects. The polyps often sport extravagant arrays of color. The coral branches can be photographed at night to show the natural process of coral life.

Some species exhibit different colors at night than they do during the day. Showing the contrast adds an educational dimension to a slide show and also provides the photographer with an educational purpose for the pictures. Another species that makes an interesting nighttime subject is the parrot fish. Sleeping parrot fish secrete a film at night, surrounding themselves with what appears to be a plastic bag. Tucked under a rock or in a niche in the coral, parrot fish sleep undisturbed by night prowlers seeking out their food by scent. Showing the parrot fish at night in its plastic sleeping bag makes an interesting contrast when projected with slides illustrating their daytime coral nibbling activities.

Shells that come out at night to feed also provide interesting studies of adaptive behavior. Cone shells in the South Pacific, for example, hunt the reef at night, their poisonous darts ready to sting and paralyze small prey. The macro or close-up photographer can enjoy an infinite variety of picture possibilities just by concentrating on molluscs. Cowries also sport magnificent mantles and are commonly seen moving over rocks and coral at night. During the day, shells seek shelter under rocks or in the recesses of coral. These and other life forms rarely seen during the day come out at night to hunt and feed.

Framing a subject and centering it is more difficult at night. The decreased light makes it hard to see the subject through the optical viewfinder. Here again, the pilot light mounted on the strobe is helpful. Some divers have improvised with miner's hats or rubber hoods with an extra piece of neoprene glued on top. A thin dive light is rigged on the hood, leaving the diver's hands free. Commercial diving helmets with a self-contained light imbedded in the fiberglass may look convenient, but they are uncomfortable to wear and restrict head and neck movement, making them impractical for the underwater photographer.

Night diving requires some special precautions that photographers must take into consideration. A personal experience illustrates the

125

point. Two companions and I had moored our rubber Zodiac over a familiar reef off the coast of Martinique. The sun was setting as we prepared our camera gear for a dive over the familiar surroundings of the reef, located a few miles offshore. When darkness fell, we rolled backward into the water. An hour later, tanks empty and cameras full, the three of us surfaced. No boat. It was there someplace, but we couldn't see it. The swim back to shore was long and tiring, and three embarrassed divers then had to beg the use of another boat to go out and retrieve their own.

Inexpensive blinking strobe lights hung ten feet below the hull of a dive boat will give night divers orientation during the dive and a homing beacon to find the way back. Lights on a mast or raised oar and a lookout left on board the boat to protect divers from surface traffic are other precautions that make good sense.

Remember that underwater communications have to be lighted during a night dive to be seen and understood. When signaling a diving companion, do not shine a dive light in the person's eyes. It will temporarily blind the diver and cause a moment of disorientation. Common sense, advance planning and adequate, long-burning lights will make a night dive an underwater photographic adventure well worth the effort.

Aquarium Use

While most nature photographers stick to the open ocean to capture their quarry on film, an aquarium can provide a handy means of preserving smaller marine life for future use. One photographer, obsessed with nudibranchs, began taking close-up photos one at a time, then matching couples and triples of the same species. Of course, it is nearly impossible to find two or three nudibranchs of the same species on every dive, so the photographer would dive with empty plastic film containers, fill them with water so the pressure would not crush them, then gather all the nudibranchs he saw. As the obsession grew, the photographer would pass out empty film canisters among all the divers on a boat and offer rewards for nudibranchs.

The result of this "bring 'em back alive" enterprise was a collection of rare nudibranchs which lived in the aquarium by day and would be

126

taken out in clear water by night to be photographed in the natural environment. Having an aquarium handy also makes it possible for a photographer who happens upon a specimen while diving without the proper lens to collect it and keep it alive until the diver can get back in the water to take the picture.*

Some of the larger marine aquariums provide opportunities to photograph exotic fish, one of a kind specimens that a photographer would only rarely encounter in years of diving in the open water. A staff of divers feed the fish, clean tank windows, perform maintenance and care for the specimens. The curator of Boston's New England Aquarium occasionally will give a photographer special permission to enter its large circular tank with scuba equipment. One of the special residents of the aquarium is Snaggletooth, a fairly large sand tiger shark with a deformed jaw. Snaggletooth's appearance is particularly menacing because the bottom rows of teeth protrude. Another excellent marine park is Miami's Seaquarium. The Seaquarium collection of marine mammals is one of the best in the world, and photographic possibilities abound.

Aquariums provide an opportunity to photograph exotic fish, but beware of reflections on film caused by the large glass windows.

* See color section.

127

Taking pictures in a large marine aquarium can be a difficult and tricky business. Large windows designed for visitors to look through can cause reflections on the film. If a realistic shot is desired, it is often hard to isolate the specimen from its background or other fish. Using a wide-angle lens, working close to the subject, and stopping down as far as possible are the best ways to eliminate unwanted background. Because aquarium tanks often lack perfect clarity, back-scatter is a continual problem. It is best to work in an aquarium before the animals are fed and the water becomes clouded or has particles floating in it.

Aquariums sometimes provide opportunities for dramatic encounter shots that would be difficult or impossible in the open ocean. Pictures of two or three species together in the same frame add impact to a still picture. If the photographer is skilled in composition, the frame will look like it was taken in the natural environment.

Diving in an aquarium for the first time, however, can be a unique experience. It is often better not to take a camera in the water on the first dive. An artificial current in the tank is created by water jets. A preliminary exploration dive will also give the photographer a chance to get used to the presence of large sharks, morays, turtles and other animals in such a confined area. Before attempting a photo dive in a marine aquarium, the novice is best advised to listen carefully to a

Captive species can be photographed in encounters that might be rare or impossible in the open ocean.

briefing by aquarium divers and staff. The fish, for example, may be used to being fed by hand, so it would be wise to avoid the same movements aquarium divers use to feed their charges. This can save nipped fingers and avoid having fish gang up in front of the lens.

Shipwrecks

Mysterious and ominous, always romantic, shipwrecks are photogenic alone or can serve as marvelous backdrops for all manner of underwater photography and

Fish feeding at the Miami Seaquarium

filmmaking. It is amazing how many editors ask to see publishable pictures of an entire shipwreck standing upright on the ocean bottom. Even editors of marine-oriented publications often fail to recognize the difficulty of getting such a leviathan structure in full frame underwater, especially when that water is far from crystal clear. An intact shipwreck upright on the bottom, not upside down or on its side, is a special event. In most areas of the world a shipwreck can be explored only a few feet at a time. Given subdued natural light, particulate matter in the water, and general lack of clarity, photographic dimensions are usually far less than would be needed to photograph an entire shipwreck sitting upright on the bottom.

Regardless of how much of the ship remains intact, wreck pictures produced by using a combination of natural light, strobe and the light from a diver's underwater light still hold fascination. Appealing photos or film scenarios can be made with the photographer or camera operator positioned inside the shipwreck and shooting out from behind broken sections of the hull, through portholes or hatchways. The model swims into the frame in silhouette as the natural light or a

129

Shipwrecks add a sense of adventure to photography. Shown is the wreckage of the freighter *Irene* off the rocky shore of Northern Scotland.

strobe lights the inside of the wreckage. The model can hold a light, shining it toward the camera. Depending on the distance from the camera and the intensity of the diver-model's light, the photographer must take precautions against burnout or overexposure if the light is directed toward the camera lens. If the light is held too close to the model's face, it will mask the diver in a bright halo. Models thus should be instructed to hold the light away from the face and body.

A certain amount of burnout is sometimes desirable, adding a dimension of mystery to the picture. Having the model angle the light off for some of the frames, as if actually exploring the wreckage, also yields pleasing results. Instruct the model beforehand and take multiple exposures with bracketed settings using different camera and light angles when shooting out from behind shipwrecks or other underwater obstructions.

Add a hint of treasure to the scene and the photographic adventure becomes a best seller! Every town has its informal "historian" whose tales of pirates and fabled galleons are made more lucid with a drink or two at the local pub. Or there'll be an introduction to someone's

130

granny who, with a little coaxing and some charm, will come up with an artifact or two fished out of local waters. If she's willing to pose with the "treasures" and share the family story, the shipwreck pictures you take will have a tale to tell. An interesting yarn is what documentary photography or filmmaking is all about.

A little research in the local library or historical society will produce tidbits of information that will enliven any slide show or film scenario—how the ship was lost, eyewitness accounts of the sinking, the legend and folklore that added to the mystique of the haunting shipwreck scene. Such bits and pieces of local color are easy to get, usually just requiring enough interest to ask and the patience to discover. A simple diving holiday can be turned into a real adventure off the beaten path with the help of a willing disposition and nimble camera. Original approaches, both above and below water, combined with a little imagination will provide an interesting photo-documentary that will be fun for the photographer as well as the audience.

Snooping Around

A cave is not a cave when it is only a little hole in the coral. A creative photographer, however, can make a small hole look like an impressive grotto when the situation is handled with some extra effort and enthusiasm. A diver posed on one side of the recess, exploring it with a light and peering in and about, makes a simple hole or archway seem, in the picture, like a grand discovery. Creative lighting techniques that take advantage of side lighting with strobe, slave and fill lighting can accentuate some features and make others appear distant and dark, adding to the mystery.

Real caves provide opportunities for shooting divers in silhouette, either vertically or horizontally against the entrance. The impression is stark, especially when the model has been instructed to remain still for a few seconds at the entrance in a striking pose.*

Snoop around. There isn't any underwater setting that doesn't have some point of interest or offer some bit of knowledge to the curious. At one time I participated in a project to document shipwrecks abandoned in the backwaters of New York harbor. Interesting

* See color section. 131

Harbors and bays near home provide many photographic opportunities.

sidelights into America's nautical heritage created articles and a slide show that was very much in demand. There are photographic possibilities that tell a story in almost every corner of the sea, as well as in lakes, rivers and harbors near home. Imagination and the ability to communicate a feeling about the subject make the difference between being able to take a picture and being a photographer with an eye and sensitivity for a subject. Shoot a story. Take advantage of every special opportunity, creatively and with imagination.

132

PART THREE

PROCESSING, PROTECTION AND PRESENTATION

As skills build and confidence develops, the photographer will want to expand his or her horizons. Underwater photography offers many possibilities for continued growth, and exploring these possibilities can be both rewarding and fun.

In addition to experimenting with technique and subject matter, the photographer can dwell on the actual making of the picture—the development of the exposed film and any other operations necessary to prepare the final material for viewing. Finished product in hand, some photographers may then want to do more with the pictures than just look at them and store them away.

Taking photographs with the hopes of selling them for publication can create new goals and add an element of excitement and purpose to

the art. At the same time, the photographer who sets out to produce an exceptional slide show for viewing by family, friends or a science class at the local school can achieve an even more direct sense of self-satisfaction when the presentation captures the attention and imagination of the audience. Regardless of one's skill level or personal goals, presentation techniques can dramatize and enhance the final version of a photographer's efforts.

CHAPTER EIGHT

PROCESSING AND DUPLICATING

"A film can be correctly developed only once," a popular firm sloganized. One of the most frequent questions a professional photographer is asked is "Do you develop your own pictures?" The reply varies, but if the professional is busy, the answer is almost always no. Busy or not, there are many factors that should be taken into account before one decides to get into home developing or make decisions concerning the duplication of slides.

Film Processing

Taking time into consideration, home developing can cost several times the price of sending the color slides out to Kodak. The cost of the slide mounts alone have risen to such an extent that mounting supplies become a significant expense. A recent price check on Kodak's E6 home processing kit for Ektachrome slides showed that, taking the

135

maximum number of rolls that could be processed with the materials in the kit and adding the cost of the slide mounts, it is cheaper to buy Kodak prepaid processing mailers in the same store and be assured of professional quality and convenience.

Volume is an important consideration in setting up a home laboratory. The more rolls of film that are developed, the lower per unit cost. If the chemicals must be left inactive for periods of time, they will disintegrate and not yield good results.

In underwater photography, probably more so than in other areas of photography, seeing the results right away can allow immediate adjustment and correction. Since there are more variables involved when shooting pictures underwater versus topside, it may be a good idea for a group of photographers going on a dive trip to invest in a Kodak E6 processing kit so that a few sample rolls can be developed on location to test and check on the equipment and exposures.

Shooting and seeing the results right away is by far the best way to learn. One underwater photographer took a job operating a resort photo lab, and within a year his pictures showed dramatic improvement. In fact, his work compared with the best produced by photographers with twenty years of experience. The reason was easily explained. The photographer shot his pictures in the morning and developed them that afternoon. There were scores of wasted rolls, but the daily learning process was of incomparable benefit.

Black-and-white film processing is easy and can be done in a darkened bathroom. With the advent of Kodak's E6 development system for Ektachrome and Fujichrome film, it is also relatively simple to develop slides. Unlike the older E4 processing, the E6 chemicals, while potentially dangerous, are far less toxic.

The temperature range allows flexibility. Using a scale provided, varying time in solution permits temperature to range between norms. Temperature ranges of various solutions can run from 75°F (28°C) to 103°F (approximately 40°C). Where the developing line is in a sink, various heaters can be purchased to keep the water bath at a constant even temperature for all of the developing trays. The ideal bath temperature is 100.4°F or 38°C. When this temperature is kept constant, time in the first developer is six minutes. There are seven baths and two washes required for the E6 Sink-Line Batch Processing

136

system of Kodak.

It is a simple matter to "push" Ektachrome film while it is being processed. Pushing film means developing it at a higher ASA than rated. Ektachrome film that has been mistakenly underexposed or overexposed in shooting can be corrected in developing. For 64 ASA film to be pushed to 200 ASA, the film is agitated in the first developer bath an extra few minutes. Kodak provides a guide to compensate for underexposed film. If the film is 2 stops underexposed, the time the film is agitated in the first developer should be increased 5½ minutes; 1 stop underexposed film should be agitated in the first developer an extra 2 minutes. If the film is overexposed by 1 stop, then the time in the first developer should be decreased 2 minutes. These ranges are approximate, and while pushing film or compensating for its under-exposure or overexposure permits acceptable results, the quality of pushed film is not as good as when the film is processed normally.

Kodak's Ektachrome P800/1600 film has been specially designed for E-6 push-processing yielding higher effective film speeds. The film is ideal at low light levels. While the grain structure is evident when shot at 1600 ASA, P800/1600 push film holds together better than normal Ektachrome or comparable film when push-processed.

A booklet describing the Kodak E6 processing procedure for Ektachrome films can be obtained from the Eastman Kodak Company, Rochester, New York 14650.

With E6 processing, great care must be exercised to prevent contamination of the solutions. All equipment must be washed thoroughly before and after use. Thorough washing when required during processing is also critical. Complete agitation during developing will eliminate air bubbles and insure a uniform chemical reaction. The solution must reach all of the film.

Color balance can be achieved by running a Kodak control strip through the baths and comparing it to a controlled Kodak strip. Acid or base can be added to the color developer solution to compensate for color imbalance. One milliliter per liter of solution of 5N sulfuric acid (H_2SO_4) changes the color step spread about -0.05 when the color balance is yellow. This is where the blue density plots above red and green densities. A 5N solution of sodium hydroxide (NaOH), one milliliter per liter of solution, corrects for blue color balance where the

137

blue density plots below red and green. Caution should be exercised in handling and preparing acid and base solutions. Follow manufacturer's directions explicitly to avoid burns and dangerous chemical reactions.

Chemical solutions in the Sink-Line processing tanks must be replenished or disposed of according to the manufacturer's prescribed recommendations. Small numbers of film rolls can be developed in pint-size tanks. However, the most practical home lab set-up is the Batch-Line sink method. Machines are sold for the E6 processing which automate some of the steps, particularly the agitation. These machines, such as the Colenta processor, are expensive and probably beyond the range of most amateurs. Many pros who process their own film still prefer the Sink-Line process to machines.

The E6 processing kits are adapted for small tank processing, which is quite adequate for one or two sample rolls at a time. If one has the space to set up a home lab, the Sink-Line system is practical and economical, providing there is enough volume.

For immediate equipment testing, the Polaroid 35 mm instant color and black-and-white slide film is a great boon to underwater photographers. Mistakes can be corrected at once, exposures analyzed, and defective equipment fixed before the next dive. Instant Polaroid film ensures that test rolls can be processed and viewed on site, minutes after surfacing from a dive.

Famed French underwater filmmaker Christian Petron has set up his film truck with developing baths so he can process Ektachrome 16 mm movie film test strips. On one film assignment, I found that several rolls of film had been ruined because of a hair on the back of my camera lens. Had I a system like Christian's, the problem would have been corrected before wasting more film and, more importantly, before getting on the plane for home, only to get the disappointing news when the film came back from the lab.

Those photographers seriously interested in filmmaking and using 16 mm film should first obtain catalogs and price lists from the best professional film labs in the business. In New York City, DuArt Film Laboratories, TVC Labs and Control Film Labs all perform work to the highest professional standards. These labs are used by major television and motion picture companies to process their films.

138

Discussing a film project in advance with the pros at these labs will insure customized and individual service. All of these labs will process film overnight and can have a work print ready for viewing almost immediately if the job is important enough.

Professional filmmakers find a lab that suits their needs, develop personal contacts with the staff, and often remain with that lab over the course of a working career. The labs I have mentioned are not only professional but adhere to the highest quality controls. They will also take a personal interest in the work of a filmmaker—an important consideration when choosing a motion picture lab.

Motion picture film can easily be transferred to video tape by professional labs like DuArt and TVC. These transfers are made on special machinery and are available for home use or on one-inch tape for television broadcast. Most movies broadcast by television today are shown from one-inch video tape and not the original 16 or 35 mm film. The professional transfer is of high broadcast quality.

Duplicating Slides and Black-and-White Conversion

Slide film enables the most flexible use of underwater pictures. While a color print negative can be converted into a slide by Kodak or any professional laboratory, color prints and color print film should be limited to pleasure dives, where the photographer desires snapshots of the underwater experience. Likewise, black-and-white film can yield contrast and artistic quality, but underwater photographers often lament having shot many early pictures in black and white, despite their artistry. It is a relatively easy matter to duplicate color slides and, with the same equipment, convert them to black and white.

The projection of original slides should be avoided. Not only can the slides be harmed by even one or two projections, but frequent projection, especially if the frame is left projected for a few seconds, will warp, burn out and eventually destroy the slide. Copies of slides can be made commercially. They cost from about 25¢ to 75¢ each. Professional labs may charge as much as $2.50 or $5.00, but it is rare that the so-called pro labs do a better job than Kodak and certainly never better enough to merit the difference in price.

A handy device for the SLR camera owner is a slide copier. Usually

139

made in Japan, copiers attach in place of the camera lens and have many other uses, including making titles, sandwich slides and black-and-white conversions. The slide copiers come with or without zoom possibilities.

Creative use of a slide copier or bellows attachment can even improve the original picture. The copy will have some of the particulate matter filtered out, in some cases getting rid of dirt and unwanted back-scatter. Unwanted material on the original slide can be painted or air brushed out so it will not appear on the copy. The zoom feature enables one to frame a subject or come in on it and emphasize it in the resultant copy.

Kodak sells a special Ektachrome slide-copying film, or slides can be copied directly onto normal Ektachrome film. Some filtration may be required. Filter information is contained with the emulsion number of the slide-copying film.

With the copier attached to the camera, the slide to be copied is inserted in the holder. The camera can be operated on automatic or set for the desired shutter speed. Light sources can be sunlight (if done outside in the bright sun), flash, studio light or the projection lamp of a slide projector. With artificial light the camera will have to be moved until the lighting appears evenly dispersed over the frame to be copied. The camera and copier may be set up on an improvised stand, or a tripod can be used to steady it. If long exposures are desired, then a cable shutter release should be used to avoid movement.

Many innovations have come onto the market for slide copying. Some photographers use bellows attachments with lenses like the Micro Nikkor 55. While much more expensive than the $35 to $75 slide-copying device, bellows have many applications for close-up land photography. Slide-copying machines, some with built-in filters, may be practical for the professional photographer who does a lot of copying work. Keep in mind that some experimentation may be required with different light sources and filters to obtain desired color balance in copies.

Black-and-white conversion from slides requires no filtration. The SLR camera can be loaded with black-and-white film, set appropriately, the slides inserted in the copying device and shot directly onto the film. As a rule, it does not pay to shoot black-and-white

140

underwater. Where required for newspapers or magazines, the slides can be converted.

Polaroid professional black-and-white slide conversion film has been around for a long time. Labs would produce a large Polaroid negative using special backs on their cameras and a copying attachment. Until now, this process was a fairly costly luxury. Today both color snapshots and black-and-white prints and negatives can be made from slides quickly and easily with a new Polaprinter from Polaroid.

I first saw the remarkable vending machine in a Parisian photo store. Customers were standing in line with their slides, waiting to get prints made. They would insert the slide in a slot, pop in coins, and Voila!—a color print would come out. As soon as I got back to the U.S., I saw that the ingenious folks at Polaroid were marketing a slide-to-print conversion device that used their instant film. The device was quick and simple to operate.

The Polaprinter uses Type 669 color and Type 665 black-and-white positive/negative film. The 8-exposure cartridges slip in the

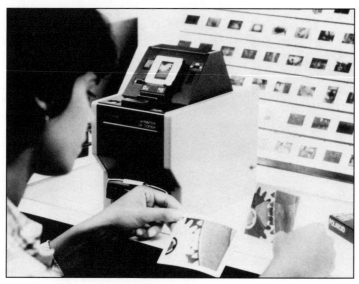

Instant slide-to-print conversion—including negative—from the Polaprinter.

141

bottom of the machine. The slide can be cropped, top or bottom, by moving a framer. A filter holder enables gelatin filters to be used for color balance. The slide is inserted into a slot in the Polaprinter, and a button triggers exposure. The film is pulled out and a minute later (30 seconds for black and white) the print is ready.

The black-and-white print must be coated with Polaroid's glossy print protector material. A negative is also produced with the black-and-white print. The negative must be clarified by running water over it, using care to peel away the excess paper and to avoid hand or eye contact with the caustic developing jelly. A rubberlike black coating washes off the negative and is discarded. Polaroid recommends a hardening process for their black-and-white negatives, which tend to scratch easily. Polaroid provides a formula for the hardener, which is made from potassium alum, sodium sulfate and water, although I've found that washing the negative in plain water is perfectly adequate.

Rapid access photographic prints as big as 12″ x 18″ can be made with the mechanized Kodak Ektaflex PCT processor. One-at-a-time prints from negatives or transparencies require only one chemical, and no washing is needed.

142

The Kodak Ektaflex printmaker, model 8, is a convenient, tabletop processor that makes possible one-solution printmaking from either negatives or transparencies.

The black-and-white 3¼" x 4½" print is suitable for publication. Some experimentation with the contrast and exposure controls on the Polaprinter will lead to quite good results. The great advantage with the Polaprinter is that conversions are quick and easy and can be done at home.

143

The Kodak Ektaflex PCT negative film is peeled away from the paper to reveal a fully saturated color print in as little as 6 minutes after the film and paper are laminated into a "sandwich."

144

CHAPTER NINE

CARING FOR PHOTOS

Once you have invested your time and energy in taking photographs, you owe it to yourself to protect them from damage and to store them in a manner that will facilitate ease of retrieval. Sorting and selection, as well as the shaping of slides and film into a cohesive "story" or artistic plan, will depend on the use of appropriate editing technique and equipment.

Care and Storage of Slides and Film

Secure storage with easy retrieval of film stock is important to busy photographers. Selecting a suitable storage system at the start of a photographer's career is desirable. Photographers invariably begin by trying to put everything in carousel trays. This procedure is often abandoned and replaced by a system that results in individual slides being stored in plastic sheets. When the plastic sheets become too expensive, inconvenient and time consuming, photographers seek out compact boxes that store flat and hold several hundred slides.

Depending on the activity of a photographer and the frequency of

the need for film retrieval, one of the best systems is to keep slides in their original boxes and store them in a 27- or 30-drawer file cabinet. These files are made by a number of companies, usually for legal blanks. The cabinets permit neat storage of some six hundred boxes of slides. The 36-exposure boxes fit two across and about eleven deep. Each drawer holds about 22 slide boxes.

Before sending slide film in for processing, write the number that corresponds to a notebook entry that identifies the roll of film next to the name on the return address label. Since that label comes back with the film after processing, the photographer has a control and will not have to puzzle out which roll is which. A photographer in the field can quickly number each roll as it comes out of the camera by inserting a penned notation in the film can or using a marking pen or diamond-pointed scribe on the roll itself.

Note the subject matter of the photos in a small notebook. Mark down the exposure and comments about the film. This simple procedure not only will help identify errors later but will also be necessary if the film gets lost in processing.

Underwater picture taking is often hit or miss. One cannot be positive that each picture will be perfect. It is a good practice to make notes concerning specific photographic situations. If something goes wrong or doesn't turn out as anticipated, the problem can then be corrected on subsequent dives.

Film boxes should be stored together by job. If a trip is to Tobago, each slide box should have a typed label: TOBAGO 21. The number corresponds to the number in the field notebook. The Tobago slide boxes stay together in the file drawer.

Cataloging slides can be done by hand on index cards, in notebooks, or by computer. When cataloging slides, give each subject a card. Make notes on the card indicating where slides of that subject can be found. For example, cards for fish like grouper should list the slide box and a notation that will help refresh the memory. The card should be headed GROUPER and under that a listing, Tobago 21— good shot, spotted G., mouth open. Some professional photographers use computers to keep track of their stock shots. Amateurs with a home computer may well want to program their film catalog instead of using cards or notebooks.

146

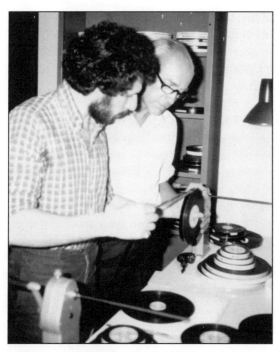
Filmmaker Stan Waterman examining movie footage stored on cores.

Movie film presents a different storage problem. After editing, the original work print (or, in the case of reversal film, the original itself) is composed into one film and kept in a film can. Outtakes are labeled and stored on separate cores or in cans. The negatives are organized by job and stored in boxes. Storage in a cool, dark place free from humidity is important.

Black-and-white still film negatives can be stored in plastic sheets. Contact proofs of what's on the negatives can be kept in a notebook, numbered to correspond with the negative file. Black-and-white prints can be stored flat in a letter file.

Storage of slides in boxes that do not keep them fairly rigid results in the warping of their cardboard mounts. Warped mounts will not pass or drop through the carousel projector.

Many underwater photographers, once they've acquired some confidence in their results and begin to develop pride in their pictures,

147

get the "improvies." Improvies result in slides being preserved under glass mounts or in special plastic frames. This expensive and tedious process is unnecessary. A professional will duplicate the originals and put them in a safety deposit box. From that point on, the original is not used or projected.

It is never a wise idea for a professional photographer to project original slides. The heat can blister them; a defective projector can jam or scratch the slide; and the lamp will eventually affect the color. A lecture set of duplicates should be prepared and the originals filed.

Never give an editor an original of anything. One might as well put the original slides or manuscripts in a pig pen as entrust them to an editor. Even the clean editor who doesn't eat bonbons or drink coffee from a strainer gives the slides to an anonymous layout room, where the mounts will be cut, the slides scratched, and the edges written on with a scribe. The layout room passes the slides on to the lithographer, whose office is invariably in the basement of a sewage treatment plant. None of these individuals answer directly to the photographer and rarely answer to the editor. They remain nameless, and if the editor doesn't get the film back after printing, the last person to have had it can never be located.

A few conscientious outfits are badly maligned by these generalizations, but they remain an endangered species. Editors who insist on originals for photo reproduction or for making color separations used in printing should be entrusted with them only at the last possible moment and then by special arrangement to insure that the editor is impressed with the value of the pictures and will handle them with care.

A casual or amateur photographer often values photos more highly than a professional, since they are sentimental souvenirs of a trip or pleasant experience. The same principle applies to amateurs when dealing with editors. Most editors can use duplicates for reproduction.

Remember to store film and slides in a cool, dark place. In a tropical environment, slides will be attacked by fungi. To prevent damage, slides and film should be stored in a dehumidified room or kept in an airtight sealed plastic box with silica gel packets.

148

Editing Equipment

Professional filmmakers either rent space or invest several thousand dollars in editing equipment. The key to successful film-making is good editing. Editing stills is easier than editing film, but both jobs are tedious. Editing a picture story into a finished product, however, can be a rewarding endeavor for the professional as well as the ambitious amateur.

Sixteen millimeter or larger film editing benches consist of a screen and two or several feeder reels that permit the editor to view the film at various speeds, hear the sound, then cut, store or splice as required. Smaller versions of the film editor are available for Super Eight films. Since Super Eight is a smaller film, it is more difficult to edit. The same preview and selection process is required, however.

A film editor must shape a series of takes into a cohesive story. One amateur photographer fabricated a simple device to hang and sort film clips during editing. It is nothing more than a board with nails driven into it, spaced slightly farther apart than the width of the film. The board is suspended about six feet off the ground on a stand. As the film is edited and cut, it can be hung over the board, separated by the nails. A professional version consists of sharp hangers and a lined lint-and-dust face bin. The film clips are hung by their sprocket holes and allowed to drape into the bin. The clips can then be arranged in sequence and spliced together.

Slide sorters or light tables are available in most photographic supply stores. Sorters that hold one or two rolls of film are inexpensive and more important to the editor than projecting the slides. A whole roll can be viewed in the order in which it was shot. Magnifying glasses or loupes can be used for technical analysis. Seeing the slides laid out in series is the first step in editing.

Light boxes or light tables are sold commercially but are more expensive than warranted. Once the small sorter is outgrown and space is available for permanent installation, photographers buy or make large light boxes or slide-sorting tables. The cost of a large commercial slide-sorting table can run several hundred dollars. Apart from its fabricated metal stand, it is nothing more than two or more neon light tubes behind a piece of clouded white plexiglass on a stand.

149

Slide sorters allow the photographer to view slides in sequence—an important first step in editing.

Neon tubes in their fixtures can be purchased in any building supply store or Sears hardware outlet for a few dollars. If one wants variable power or brightness, switches for that purpose are also inexpensive. Clouded white plastic or plexiglass is available almost anywhere. If it is not available in local hardware shops, try light fixture supply companies or commercial sign installers who use it in their displays.

Designs for the table can be simple. A plain wood table with the plexiglass on top will suffice, or the light table can be built in two parts, one flat and one at an upward angle. A quick look at commercial

150

The Visulite Briefcase Viewer—convenient, space-saving, and portable

models will suggest designs for making one's own slide-sorting and editing table inexpensively and with little labor.

One of the most practical commercially made light boxes is manufactured by Multiplex Display Fixture Company in Fenton, Missouri. Multiplex markets an attache-case-contained light box complete with two color corrected fluorescent tubes. The Visulite II portable slide and transparency viewer spreads 5,000°K light over a 12″ x 18″ plexiglass viewing area. The unit is convenient, portable and an excellent investment for the photographer suffering from a shortage of storage space. The portability of the Visulite II allows a photographer working with harried magazine editors to make a professional presentation without having to hunt for a free light box in the magazine's art department or force an editor to hold slides up to a lightbulb to view them.

Editing, like writing or painting, is difficult to teach. Good editing requires imagination, a good eye and a sense of order that creates and builds an interesting story in logical sequence. Imagination and creativity play as important a role in editing as in taking the pictures. Experience and experimentation help, but editing is a special art that some professional photographers often leave to more experienced individuals who can bring objectivity and fresh creativity to the job, making for a better finished product.

Chapter Ten

Presentation:
The Final Chapter

For most artists, writers or photographers, it makes little sense to develop a project, view the results in private, and then squirrel the creation away in a closet. In the case of photographs, the enjoyment is often in sharing the pleasurable moments or educational experiences with family, friends and local groups. The presentation techniques used in showing underwater films and slides will distinguish the professional or serious amateur from the amateur.

Some Tips for Showing Underwater Films and Slides

The key to successful presentation of slides or film? *Leave them wanting more*. I've drilled this into photography students for so long that I've begun to hear it echoed as guidelines for underwater film festival speakers and program chairpeople. Show just enough to entertain, not inflict. Ruthless editing is a hard and fast rule that

153

sometimes takes years to learn. The rule is easily stated but often difficult to implement. The most important thing for a photographer to do is to perform a little self-analysis. Simply asking yourself a question and answering it frankly will set up the frame of mind needed to be a good presenter. Am I projecting these pictures to entertain and educate others, or am I showing off and taking a personal ego trip?

An anecdote will help emphasize this point better than any lecture. A wealthy businessman, immersed in a world of ambition and cut-throat competition that had made him an overachiever, took up photography as a pressure reliever. Instead of relaxing, he bought the most expensive underwater equipment, set off on the most expensive worldwide tours, and captured some wonderful pictures on film. Since the psychological drive was neither enjoyment, professional enterprise or generosity, this photographer went on an ego trip every time he returned from a diving trip.

Although the man was, in fact, an excellent photographer, viewers would groan with dismay when the tenth carousel was inserted and the midnight hour approached and passed. The man had no feeling for his audience. Viewers would groan and talk behind his back, mocking his ego. The shame was that many of the pictures were truly excellent. Fortunately, realization finally dawned on this photographer, and the boring narrative, dripping with uninteresting drivel as each slide was passed, disappeared. The slide shows were cut down and the rapport with the audience was much improved.

Entertain your audience. Show only the best slides and keep the presentation short enough to make them want more. If you are not a good speaker, play music. Don't dawdle over slides; keep the show moving. Try not to state the obvious. "This is a picture of Niagara Falls" or similar commentary is hard to take over the length of a slide show. Leave some things to the audience's imagination. The presentation should be enjoyed, not endured.

Planning a good presentation begins by planning the pictures one is going to take. People want to see people. They are interested in what a person thinks, feels, experiences. Pictures convey this information by the expression on a subject's face or body language. Animated looks, gestures and expressions add interest to a picture. Models should be informed of the photographer's goals and given tips about facial

154

People in pictures add zest and interest. Here the
caretaker of Bermuda's Maritime Museum tells wonderful
shipwreck stories.

expressions and gestures in the dive briefing.

Putting together a slide show or movie footage is no different than
writing an article, play or book. Mix reds, oranges, surface shots and
divers into the general presentation. Make sure at least 25% of the
slides are surface shots—people getting into and out of dive gear, the
boat, etc. Action pictures add zest to the show.

A story line should flow naturally. A would-be presenter can look
over a good magazine like *National Geographic* and study the way
the material is presented. Picture editors and layout artists work
laboriously on order and sequence to develop a picture story line.

A slide show can start off with a punch or can build to a moment of
excitement, an underwater encounter or happening. Shots of whales,
dolphins, manta rays, morays or sharks all lend themselves to

Include surface shots in your slide show to add variety to the presentation.

dramatic encounters. People also enjoy a good laugh. If the laugh is at the expense of the presenter and in good taste, so much the better. Something amusing that happened during a dive, even something silly, can change the audience's receptiveness and provide a humorous intermission. Should the amusing anecdote fall flat, drop it naturally. If the audience does laugh, don't try to talk over the laughter. Wait until it subsides.

Attention span will vary with different audiences, but a sensitivity to the needs and interests of the people around you will go far in capturing and holding their interest. The church adult education forum, for example, might like to see pictures of churches in Tahiti and be given a brief missionary history of the islands. No matter how interesting the subject, however, physical discomfort and distractions

156

Don't forget to add some humor to your underwater slide show. A session can seem very long without some lighter touches.

can destroy a presentation. Anyone who has had to sit through a lecture in an unbearably hot room knows the feeling. Experienced lecturers always check out the facilities beforehand. If it is noisy with the windows open, close them. If a shade is broken and too much light is getting in, fix it. If it's too hot or too cold, try to remedy the uncomfortable situation before the audience arrives.

Microphones, PA systems, remote controls to change slides, broken or defective projectors or a blown projector bulb can be disconcerting once a show is underway. Take an extra fifteen minutes before the start of a slide show or projection to check things out. Do not keep an audience waiting, realizing too late that the extension cord will not reach the outlet.

Think of all the things that can go wrong with your equipment and make allowance for contingencies by having a spare bulb or extra extension cord. Getting there early and planning ahead will save the presenter and the audience from unnecessary anxiety and waiting. A show that goes off smoothly is usually one that has been well planned.

Use of Music, Sound and Special Effects

The proliferation of small cassette tape recorders has been a boon to the amateur photographer. Sound effects add a special quality to a film or visual presentations. This lesson came across clearly when some friends and I were looking over some shark sequences shot in Tahiti. Previewing the footage half an hour before we were to show the just-cut film to an audience, we agreed that it was flat. No movie lights had been used, and the footage was very blue. A so-so film. A sound engineer, observing our backstage plight, stepped forward. "Do you want me to sort of fill in sound effects and music when you show the film?" he asked. "It won't be great because I'll be doing it live, but I'll try." We accepted his offer enthusiastically.

The resulting presentation was great. The film was dynamic—electronic sound effects, suspenseful music, pretty sounds. The audience was thrilled and ended up enjoying a so-so film. The lesson is obvious—don't neglect the dynamic nature of sound!

Pictures of ships sunk during war can be shown with documentary shots of the battle. They can be viewed with background sounds recorded from a television war film of planes attacking ships. The sounds will animate the documentary shots.

Drama can also be injected into documentary shots by using a close-up lens, like a 55 mm Micro Nikkor, to shoot some historic or archive pictures. As long as it's for non-commercial use, no one will usually mind an amateur taking a government picture out of a book. Use slide film to reproduce the picture, even if it is a black-and-white photo. The book or photograph can be taken outside in the sunlight to take the picture. Natural sunlight is best if one does not have access to a copy stand or special studio lights. Black-and-white photos can likewise be copied or converted into slides. Special film is available for this purpose, and every professional camera store will be more than willing to help the photographer select the right film and explain the technique. Black-and-white photos can be converted into slides commercially at a relatively modest price ranging from about $1.50 to $2.50, depending on the laboratory. Using the new Polaroid instant slide film will give quick results and immediate projection.

Once lecture slides are put together in a sequence, dedicate a

158

carousel to them and leave them intact. If one does not want to project original slides, have the lecture series duplicated. Store the originals and keep the dupes in a tray. When asked to show slides, you can then avoid the usual reply, "Oh, I don't have time to sort them out and put them together."

Getting Your Photos Published

Underwater photos are generally in great demand by newspapers and magazines. Getting photos published should not be the goal of the amateur photographer, but rather personal enjoyment and the satisfaction of developing new skills. Projection at clubs and local underwater film festivals will also bring satisfaction to diver-photographers who have reached a certain level of competence with their equipment. As for those who remain determined to sell pictures to the major magazines, here are some suggestions on ways to get started.

Editors of dive magazines are besieged by amateurs who send in cute pictures of fish. If you want to hit it off with any of the diving publications, send them news pictures—something that records a special event their own staff cannot cover. An underwater rescue training program given locally, pictures taken of a local artifact show or underwater film festival, a shot of a new shipwreck, even club news will attract their interest. As an editor of several magazines, I've noticed that once we get to know a helpful photographer who has provided good news pictures we've used to fill space as layout required, the chances are quite good that the magazine will be open to later feature submissions by that photographer.

Don't overlook the local newspaper in your community. A picture about your club's diving activities, some special artifact find, or an area dive site all have eye appeal to the editor in search of community news. If you want to get published, examine local options first. Don't dive headlong into markets where competition is fierce.

A ruthless publisher of a magazine recently commented that, in spite of published rates, he gets away without paying photographers. "Their tongues hang out for the publicity value and exposure they get," he said, adding that there are hundreds of amateur

photographers who crave to get published. He went on to name well-known photographers he has stiffed and will continue to stiff because they are hungry to have their work remain before the public eye.

Don't be hungry and don't compromise. If a magazine or newspaper pays, then demand payment. There are many non-paying markets for your work that provide reputable ways to gain exposure and fame without dealing with a sleazy publisher. Dealing with unethical publishers will end up discouraging a beginner. It is better to contribute your work to a supportive, non-paying market. A few kind words and the pride of seeing your pictures in print in a publication which appreciates your contribution is important.

In the same vein, don't be misled by professional magazine photographer forms and standards. An amateur who sends off a selection of slides with demands published as guidelines for pros will get them back. The editor of a small magazine will simply return your material, because these guidelines are akin to what union demands would be if writers and photographers had a union. These demands and standards are laudable, but unfortunately, as the sleazy publisher said, it's a buyer's market.

Direct your initial efforts at the club newsletter, expand to the local diving council newsletter, and then send submissions to the Underwater Society of America bulletin and other dive organization bulletins. They are always looking for good pictures. If contests tempt you, then by all means enter them. Expect to win. On a local level, serving as a judge for many regional contests, I know we often had far more prizes than we had entries. The amateur club member was usually intimidated, fearing that only the professional would stand a chance. On the contrary, the amateur has an excellent chance of winning in local contests. And once a photographer can tell an editor that he or she has won a contest or two, then the photographer is beginning to build a portfolio that helps add credibility to the submission.

Putting together a portfolio works. There are times when an editor is receptive to seeing a photographer in person. Make an appointment and bring in a reasonable number of slides in plastic sheets. If you have a Multiplex Visulite II attaché viewer, bring it along as a ready means of viewing your slides. Bring the press book, along with

160

clippings about your work. It can include news about contests you've won and tear sheets from magazines and newsletters where your pictures have appeared. Be professional, not overbearing. Let your work speak for itself. Most editors remain interested in the diving experience. It is still an adventure, after all, and small talk about diving helps to break the ice.

The beginning divers I've seen develop into premier underwater photographers all share two qualities: patience and persistence. In your quest to be published, never be discouraged by an editor's rejection. Nor should you be discouraged by an editor's rudeness or the inevitable mishandling of your submission. There are rude and unethical people in every business, and the publishing business has its share.

Submit your pictures on spec, or speculation. The editor agrees only to look at them. Package the slides with care and enclose a self-addressed stamped envelope to ensure their return. Don't be shy. Drop an editor a line in the mail with a stamped, self-addressed envelope describing what you've got on film and asking for an interview. In the case of local newspapers, pick up the phone and speak to the editor.

Many publications send out guidelines for photographers. A letter to *National Geographic* or other major magazine with a request for the photographer guidelines will result in a printed set of suggestions that will stand you in good stead for any magazine. You will learn from the magazine's guidelines and begin to develop professional habits that editors appreciate.

Getting your pictures published is no accident. It is a reward that comes as the result of documenting interesting things on film and persevering until a market is found for the work. Most important, never take no for an answer. I've had articles published after numerous rejections. The last editor in line would often comment that my "rejected" submission was the best thing to cross the desk in a long time.

Study the publication before submitting. Direct your pictures to publications which seem most responsive and open to new contributors. Finally, recognize that, unless you are taking on underwater photography as a business, it is something to be enjoyed.

161

Competition is for big businesses. The natural beauty and tranquility of the oceans is ample reward for the underwater photographer. Recording this beauty on film can also be financially rewarding, as long as one sets reasonable goals and recognizes that the real profit—that of sharing the experience with others—cannot be given a dollar value.

GLOSSARY

Ambient light
The light surrounding a subject that already exists and is not supplied by the photographer.

Aperture
A fixed or adjustable lens opening in a camera through which light passes. Aperture size is usually designated by f numbers, with the larger numbers corresponding to smaller lens openings.

ASA speed
The emulsion speed of a film expressed in arithmetic values.

Automatic camera
A camera with a built-in exposure meter that automatically makes the necessary adjustments for proper exposure.

Backscatter
Reflection from suspended particles in the water

Backlighting
Illuminating the subject from behind so the subject will stand out more sharply against the background.

Bracketing
Taking 2, 3, or 4 exposures of the same subject from ½ to 1 stop over and under the meter reading, as well as the actual reading, when unsure of the correct exposure.

Depth of field
The distance range between the closest and farthest objects from the camera that will appear in sharp focus in a photograph. Depth of field is normally a function of the focal length of the lens, the distance from the lens to the subject, and the lens opening (the smaller the lens opening, or aperture, the greater the depth of field).

Double perforation film
Film with sprocket holes cut on both sides of the roll, thus allowing for more precision during editing.

Exposure
The amount of light acting on a photographic material, which is the product of the degree of illumination (controlled by the aperture) and the length of time the light strikes the film (controlled by shutter speed).

f stops
The diameter of the aperture divided into the lens focal length; the larger the f stop number, the smaller the aperture.

Flat lighting
Lighting that produces few shadows and very little contrast on the subject.

Focal length
The distance from the film plane to the optical center of the lens, with the lens focused at infinity.

Graininess
The loss of clarity or granular appearance of a print, slide, or negative.

Kelvin
A temperature scale based on absolute zero as the lowest temperature and used to describe the color of light sources. Sunlight, for example, has a 6000 K rating, and most strobes try to approximate its white light rating to obtain proper balance with color slide film.

Lens speed
The largest lens opening at which a lens can be set.

Parallax
At close distances, the difference between the field of view seen through the viewfinder and that actually recorded on the film. Parallax is caused by the separation between the viewfinder and the lens; it does not occur in SLR cameras because the photographer views the subject through the picture-taking lens.

Push-processing
Purposely giving extra development to a film to compensate for the loss that results from underexposing the film. Thus, a film rated at 200 ASA could be shot at 800 ASA, the compensation being made during processing.

Refraction
The deflection of light from a straight path as it passes from one medium (such as air) into another (water, glass) in which its velocity is different.

Reversal film
Film (such as color slide film) that gives a positive image by being reversed from a negative image during processing.

Shutter
A curtain or plane in a camera that controls the time during which light reaches the film.

SLR camera
Refers to a single-lens reflex camera, one with a viewing system which is through the lens by means of a mirror and prism.

Stopping down
Changing the lens aperture to a smaller opening; the more the lens is stopped down, the greater its depth of field.

Telephoto lenses
Lenses with long focal lengths

Through-the-lens viewing
Viewing a subject through the same lens through which the light entering the camera will pass. What you see is what you get (see *SLR camera*).

Viewfinder camera
A camera that requires estimation of the subject-to-camera distance.

Wide-angle lenses
Lenses with short focal lengths.

INDEX

167

168

L

M

Movie cameras *(cont.)*
 Kodak XL, 26
 Rebikoff, 38
 16 mm lenses, 38
 Super Eight, 25
Movie film, 22–26
 care and storage, 147
 processing of, 32–33
Movie lights, 67–68

N

Nature photography, 102–105, 111–122

Ni-cad batteries, 75–77, 87

Night diving, 123–126

Nikon lenses, 39–41

Nikonos cameras
 film advancement, 21–22
 focusing, 21
 lenses for, 19, 39–44
 light metering of, 63
 shutter speed, 17–18, 77

Nikonos V, 79–80

O

Oceanic strobes, 76, 79

Ohmmeters, 97

P

Parrot fish, 125

Photographs, publications of, 159–162

Polaroid processing machine, 34

Polaroid slide film, 34–35

Processing labs, 32–34

Push processing, 30

R

S

V

W